Formulas for painters

Formulas for painters

by Robert Massey

WATSON-GUPTILL PUBLICATIONS

NEW YORK

Paperback Edition

Edited by Judith A.Levy
Designed by Betty Binns

Dedicated to Doel Reed, N.A.

Precautions

In using the formulas in this book, be sure to take adequate precaution, as some materials can be hazardous if not handled properly, and may cause disagreeable reactions.

Your studio should be well ventilated, and you should not eat, drink, or smoke while you work. Wear a respirator whenever there is a danger of inhaling such toxic substances as formaldehyde, toluene, benzene, white lead (dry pigment), China clay, or pumice. Protect your eyes with goggles when working with substances like toluene, benzene, or lime. Gloves should be used when working with potentially irritating materials such as ammonia, toluene, benzene, formaldehyde, or lime. After working with white lead and other pigments, wash your hands carefully, cleaning under your fingernails, to avoid lead poisoning.

Extra precaution is required when heating certain materials. Alcohol, turpentine, damar and wax varnishes (which contain turpentine), toluene, benzene, and ethyl ether are all highly flammable, so you should avoid any exposure to an open flame. Note that benzene is a particularly hazardous substance, and it may be best to avoid it altogether. Another substance to avoid is laquer thinner, which is a combination of several fierce solvents.

Acknowledgments

It is difficult to express strongly enough how much one owes to the many sources of inspiration and impetus which provide the enthusiasm to carry through any protracted research or labor, but many of my sources lie within the covers of books listed in the bibliography of this volume. Max Doerner, Ralph Mayer, Rutherford J. Gettens, George L. Stout, and A. P. Laurie, through their profound and extensive research, have not only inspired and nourished this volume, but have given constant pleasure through many years. These gentlemen did not just compile dessicated data—they instilled in their writings the historical richness and excitement which delight as well as inform the serious painter.

The author wishes to acknowledge another kind of debt— to Doel Reed, National Academician and retired Chairman of the Department of Art at Oklahoma State University, whose intuitive mastery of art and whose boundless enthusiasm for living provided a kind of spiritual catapult to many struggling students.

And lastly, gratitude is due to the Research Committee of the University of Texas at El Paso, whose grants eased the tasks of three years' experiments and testing, which were so necessary to complete this work.

Contents

Paints

Mediums

Glazes

Varnishes

Fixatives

Adhesives

Notes

Tables

Introduction

Since the Middle Ages—indeed as early as the 13th century when Theophilus, the monk of Paderborn, wrote his work, *On Divers Arts*—artists and craftsmen have cooked, blended, borrowed, and stolen an amazing variety of recipes and formulas, always striving to concoct a better paint or a quicker drying varnish to insure the permanence of their works. At times, these earnest efforts were patently misdirected; at other times, they were so strange that we wonder today how any intelligent being could have expected to make a green paint from ivy leaves solely because of the greenness of the vine. But however amusing some recipes might seem today, these searchings produced substances and revealed uses which amaze us by their timelessness. Earwax and the bile juices from oxen served the medieval artist as what scientists today call wetting agents. Works of great beauty were executed on scraped lamb's skin, and exquisite altarpieces were wrought using glue made from these scrapings.

Today we have an abundance of packaged perfection in the highly developed color palettes produced and sold by many scientifically directed paint manufacturers; new, improved synthetic products are also present in overwhelming numbers. Today's painters may gain from the ease of obtaining such excellent materials, but they sometimes lose by failing to experiment—trying different glazes and grounds, or cooking up an odd combination which they've never heard of before. Happy is the painter who discovers just the right materials or techniques to suit his particular temperament. And to excite the flagging spirit of an artist

who has followed the same technique for years, no device is more effective than to have a go at a brand new—or an absolutely ancient—approach. This compilation of formulas is designed to do that kind of job: to excite, suggest, and sometimes startle the artist or art student who might enjoy experimenting.

To ease the process, nearly all the formulas are given in volume proportions; any exception to this procedure is clearly designated. Volume measure proves much simpler for the average artist, who may use units according to his pleasure and convenience—a cup, a tin can, or a baby food jar—and avoid the tedium and confusion of various tables of weights and measures. All the recipes included in this volume have been tested and tried. This is not to say that the author recommends them all equally; for in the case of differences among them, each artist must choose according to his taste and preference.

The formulas are divided into nine categories for convenience: *Sizes, Grounds, Paints, Mediums, Glazes, Varnishes, Fixatives, Adhesives,* and *Notes* (to catch anything which doesn't fit properly into any other category). At times, one formula serves as a basis for two or more substances which may be a paint, a medium, or a glaze, with only a minor change affecting its purpose. For this reason, the reader must clearly understand what is meant by each of these category labels.

Size is any substance used to coat or fill the fibers of a support (canvas, panel, sheet metal, plastered wall, etc.) If the *next* coat is composed of substances which might damage or deteriorate these fibers, it is necessary to size them for protection. For this reason, we apply a coat of glue sizing to cloth to prevent the subsequent oil ground from seeping into and rotting the cloth fibers. Sometimes a size is used simply to stiffen a material, such as cloth or paper.

Grounds are layers, or coats, which are applied to a support

to provide a desirable color and surface upon which to paint. Traditionally, most grounds are white (white lead, gesso, etc.) to offer the brightest reflecting surface for the light to act upon. This reflection of light enhances the deep, jewel-like colors produced by applying layers of glazes over the white ground. But many great masters colored their grounds, so it does not follow that the pure white ground is always the best. One can always color the white surface of a ground by applying a thin coat of color over it. This color coating on a ground is called an *imprimatura.* It is usually transparent and therefore preserves the white reflecting power of the ground.

Underpainting is the first layer of a colored design which is intended either to show through a subsequent layer of paint or to alter the colors applied over it. For example, where the painter intends to have a luminous green in his finished picture, he can use a bright yellow underpaint and then glaze over this with a blue. A sketch or drawing on the ground does not constitute an underpainting.

Paint is simply a combination of a pigment and a binder which holds, or cements, the pigment in place. Any substance whatever that serves as a cement or a glue can be mixed with pigment to make paint. The differences among the various paints lie in the different cements or glues which bind the pigments. Thus, in oil paint, oil is the binder; in casein paint, casein is the binder; and in egg tempera, egg is the binder.

Medium includes all combinations of ingredients suitable for adding to or combining with paint. Generally, a painting medium changes the consistency or make-up of a paint, rendering it more convenient for brushing or applying, or more suitable for the artist's particular technique, which may require thicker or thinner paint, faster or slower drying, etc.

Glazes are simply the binding agents which, with pigment,

compose paint, but they are used to make a paint thin and strong enough to permit the artist to brush or rub a *veil* of color onto the surface. Diluting a paint reduces its binding strength, but adding a glaze formula rich in resins enables the artist to follow the traditional procedure of painting fat over lean. Titian was devoted to the beauties of glazes and favored "thirty or forty."

Varnishes often resemble glaze formulas, but are more simply constituted. A varnish is used only to protect a finished work; and must be resistant to moisture and gases, yet easy to remove when restoration is necessary. Although many painters now dislike a glossy surface on their pictures, a satisfactory varnish is inherently shiny. Rather than leave a painting unprotected, it is better to varnish—after it has dried for six months to a year—and then soften the shine by adding a low gloss wax finish.

Fixatives are sprays or coatings designed to anchor or *fix* a pigment in place. Charcoals, chalks, and pastels especially require a fixative. In cases where the fixative is applied in order to paint over a picture without mixing the new paint layer with the old, it is better to call it an *isolating varnish*.

A final note about "fat over lean." This phrase refers to an ancient and fundamental rule in oil painting. The initial layers of a painting should be lean—low in oil, balsam, and resin content—and later layers can be fat, or higher in oil, balsam, and resin content. Think of your painting as a seven layer cake, with the leanest layers at the bottom, the fattest at the top. Remember this rule when you use the formulas in this book.

Sizes

Gelatine solution for panels

PURPOSE: Gelatine glue solutions produce an extremely clear, transparent protective coat, and dissolve easily for quick preparation.

INGREDIENTS	PARTS
Leaf gelatine	6 leaves
Water	1 pint

DIRECTIONS FOR MANUFACTURE: Imported leaf gelatine, which is packaged in the form of 3″ x 9″ thin sheets, or leaves, is of high quality and stores easily. Soak the leaves in the water for fifteen minutes, or until the gelatine swells, then heat in a double boiler until the gelatine dissolves.

DIRECTIONS FOR USE: Brush alcohol on the smooth surface of an untempered Masonite panel and allow to dry. Brush the hot gelatine solution over both sides of the panel, including the edges, and allow to dry thoroughly, overnight or longer. For a second coat, rewarm the gelatine solution and stir in two tablespoons of whiting, brush on and allow to dry. See Ground No. 10 for completing the gesso.

Gelatine solution for paper

PURPOSE: Gelatine glue solution provides a very clear bath for sizing white papers—making them suitable for painting—and gives extra strength to fragile paper. The old masters often painted in oils on sized paper.

INGREDIENTS	PARTS
Leaf gelatine	*1½ leaves*
Water	*1 gallon*

DIRECTIONS FOR MANUFACTURE: Soak the imported leaf gelatine in a pint of water until the gelatine swells to three times its dry thickness; then warm the gelatine and water in a double boiler until the gelatine dissolves. Pour this solution into the remaining water and stir well to disperse the glue completely.

DIRECTIONS FOR USE: In a tray large enough to lay the paper out flat, immerse the paper sheets in the glue solution for several hours. Remove the paper with great care, blot each sheet carefully, and hang it up on a clothesline to dry. You can also tack a dry sheet of paper onto a drawing board and brush the solution onto the sheet. Freshly sized paper can also be dried by laying it on a sheet of glass. After the paper has dried, spray it with a 4% formaldehyde solution to further harden and protect the size.

Hide glue solution

PURPOSE: Animal hide glue makes a very strong glue solution, which can be used not only as a size, but also as a very quick drying paint when mixed with dry pigments.

INGREDIENTS	PARTS
Hide glue, powdered	*1*
Water	*10*

DIRECTIONS FOR MANUFACTURE: Animal hide glues—rabbitskin, cowhide, parchment, etc.—are normally sold in dry form, in sheets, pieces, or coarse powders. Soak the powdered glue for half an hour—the thick pieces should remain overnight in the water—then warm in a double boiler until the glue dissolves.

DIRECTIONS FOR USE: Keep the solution warm enough to make sure the glue remains completely dissolved, but never "cook" it over direct heat. Brush the glue solution thoroughly into stretched linen or cotton canvas, or on untempered Masonite panels previously brushed with alcohol. Let the size dry completely before applying any ground. For making emulsions with glue, see the directions for Medium No. 28. Store glue solutions in the refrigerator to prevent spoilage.

Casein solution for panels

PURPOSE: Hard and moisture-resistant, casein solutions are useful both for sizing and for making a quick-drying, tough paint. They are excellent for sizing wood or Masonite panels.

INGREDIENTS	PARTS
Casein, powdered	2
Water	16
Ammonium carbonate	1

DIRECTIONS FOR MANUFACTURE: Buy freshly manufactured casein and avoid using old material, for casein loses strength with the years. Sift the casein slowly into half of the water, stirring to get rid of the lumps. When smooth, add the ammonium carbonate and stir; allow the mixture to stand for half an hour or more before you stir in the remaining water.

DIRECTIONS FOR USE: Plywood or wood panels need only sanding, but Masonite panels should be brushed liberally with alcohol and dried before applying the size. Brush the casein solution onto the panels, applying the solution to the front, back, and sides. When the size has dried thoroughly, use this same solution to make Ground No. 11.

Wax and resin for metal leaf

PURPOSE: This simple, easily formulated paste can be brushed or rubbed onto wood or plaster and will permit you to apply bright metal leaf with ease.

INGREDIENTS	PARTS
Beeswax	*5*
Venice turpentine	*1*

DIRECTIONS FOR MANUFACTURE: Use white beeswax where clarity is desirable, but yellow beeswax— or even dark brown—should prove perfectly good for this purpose. Melt the beeswax together with the Venice turpentine and stir together.

DIRECTIONS FOR USE: Apply the thick paste to wood (frames, statues, etc.) or plaster, carefully rubbing it into the porous surface so that no part is untouched. If the surface is warm, or the paste hot and somewhat liquid, you will achieve a smoother and thinner coat. After applying the paste, use a turpentine-soaked rag to rub down the surface and insure an even layer. Lay the metal leaf directly onto the coat and press it down firmly with a ball of absorbent cotton, making certain that the leaf is in contact throughout.

Oil for metal leaf on canvas

PURPOSE: This viscous, tacky liquid permits delicate line gilding on a painting, becomes tacky within minutes, and maintains satisfactory readiness for several hours.

INGREDIENTS

Boiled stand oil

Cobalt linoleate drier

DIRECTIONS FOR MANUFACTURE: In a clean, enameled pan, boil any quantity of heavy-bodied stand oil for 45 minutes. Do this outside or wherever the fumes will be taken out by ventilation. Although the oil will not boil violently, it might eventually froth up. Approximately one quarter of the volume will be lost in the process. After cooling, add about 20 drops of the drier per ¼ cup of oil and combine them well for very quick drying; the boiled oil alone will serve nicely too.

DIRECTIONS FOR USE: Apply the oil size in the desired design with a small, fine, sable brush and allow it to stand for half an hour or more before laying on the pieces of metal leaf. Press the leaf gently onto the size with a ball of absorbent cotton. Wait a day before brushing away the surplus leaf with a clean, dry sable brush. If the unsized surrounding area is sticky, brush on Glair (Paint No. 24) before you apply the oil size.

Starch solution

PURPOSE: Starch solutions give quick-drying
protection to paper and cloth, and permit you
to paint immediately over them with oil or resinous
paints. This solution can also be used to make a
quick-drying paint for sketching.

INGREDIENTS	PARTS
Starch	1
Cold water	3
Hot water	3

DIRECTIONS FOR MANUFACTURE: Use any vegetable
starch (flour)—rice, potato, wheat, etc.—and stir
the flour into the cold water to make a smooth,
lump free paste. Slowly add this paste to the boiling
water, stirring well. When the solution begins to
clarify, set it aside to cool.

DIRECTIONS FOR USE: Add enough water to make
the solution thin and penetrating; then brush it
onto the support (paper, cardboard, cloth, or wood).
This solution dries quickly, permitting immediate
application of paint over it. If the solution is to
be used to form emulsions with oils or resins, do not
further dilute it with water. The original volume
of starch and water nearly doubles in cooking.
Store the solution in the refrigerator, for it will
spoil at room temperature; or stir ten drops
of formaldehyde into each cup of paste.

27

Egg and water solution

PURPOSE: Egg yolk, which has proved itself one of the most permanent of paint binders, provides a very quick drying solution for isolating a drawing from an overpainting.

INGREDIENTS	PARTS
Egg yolk	*1*
Water	*34 or more*

DIRECTIONS FOR MANUFACTURE: Drop the egg yolk into a pint jar of water and shake the jar to make a complete solution. If you separate the yolk according to tradition (by drying it in the palm of the hand and puncturing it to drain the pure yolk into the jar), there is no need to strain the solution through cheesecloth.

DIRECTIONS FOR USE: Apply the solution to the gesso or grounded canvas with a large brush, or spray it on with an atomizer until the surface is fully covered. If the coating piles up at all, either the solution is too thick and needs diluting, or it has been applied too heavily; a thin coat is all that is necessary. This coat can be painted over almost immediately; oily or resinous paints will not affect the drawing under it.

Synthetic resin emulsion

PURPOSE: To isolate a charcoal or chalk drawing from further disturbance, many synthetic resins now marketed provide an excellent size, both for the support and for the drawing.

INGREDIENTS	PARTS
Synthetic resin glue emulsion	*1*
Water	*5*

DIRECTIONS FOR MANUFACTURE: Take any milky-white synthetic glue and dilute it with the water. Add more water to make the solution spray easily, or brush it on as is.

DIRECTIONS FOR USE: Where cloth, wood, or paper are to be sized, vigorously brush on the solution to be sure it completely penetrates the surface; coat the back if it has not been penetrated by the size. Where the surface has been drawn upon, and you wish to preserve the drawing without smearing it, thin the solution with water until it can be sprayed with an atomizer. The coat dries within half an hour, can be worked over with almost any kind of paint.

Hide glue solution for plaster walls

PURPOSE: A cheap, easily made solution, hide glue protects oil or resinous paints from being harmed by caustic lime or gypsum in plaster walls.

INGREDIENTS	PARTS
Hide glue solution (Size No. 3)	*1 quart*
Alum solution (1 alum, 10 water)	*1 teaspoon*

DIRECTIONS FOR MANUFACTURE: Follow the directions for Size No. 3 and make the desired quantity of hide glue solution. While the glue is warm and fluid, add the alum solution and stir together thoroughly. Alum is generally sold in the form of dry, transparent lumps, and gives both toughness and hardness to the hide glue; these lumps dissolve most quickly in *hot* water.

DIRECTIONS FOR USE: Apply this solution to any plaster wall that has dried and cured thoroughly. Keep the solution warm in a double boiler. Brush it on with a large, housepainter's brush, coating the wall completely. This coat will dry and harden rapidly, permitting the application of oil or resinous paint within an hour or two after the sizing is completed. Before you apply the paint, wipe off crystals that appear on the surface of the dry size coat.

Lime water for plaster walls

PURPOSE: Lime water acts as an isolating solution which seals the porous surface of old plaster, dries rapidly, and permits thin oil or casein painting over it.

INGREDIENTS	PARTS
Quicklime	*1*
Water	*3*

DIRECTIONS FOR MANUFACTURE: Quicklime, or caustic lime, is very reactive when mixed with water; be careful to protect your skin from any contact with this chemical. Use a wood, metal, or enameled metal container for mixing—the material becomes boiling hot. Sprinkle the lime into the water, stirring to keep the mixture lump free. Stir again after 24 hours, and add the amount of water you need to cover the wall.

DIRECTIONS FOR USE: Pour off the lime water into a bucket. Paint it onto the wall with a wood-bristle brush and let it dry. Paint over the dried surface with casein or turpentine-thinned oil. Use casein whites or the undiluted lime putty for opaque whites.

Oil, resin, wax for stone, terra cotta, slate

PURPOSE: Stone and porous ceramic are ordinarily difficult to seal, but this formulation is an effective coat which will accept both oil paint and wax paint.

INGREDIENTS	PARTS
Oil-copal solution (Varnish No. 7)	2
Paraffin or ceresin	2
Turpentine	5

DIRECTIONS FOR MANUFACTURE: Heat the ingredients together until the wax has melted into the solution.

DIRECTIONS FOR USE: With a brush, apply the warm solution in thin coats. Apply at least two coats and allow each to dry completely before you apply the next. It is advisable to warm the stone, ceramic, or slate before applying the size; either place the piece near a stove, or put it in direct sunshine. This size provides a relatively effective waterproofing treatment and darkens the stone only slightly. Apply Ground No. 16 over this size.

Grounds

Lead and copal for commercial canvas

PURPOSE: Some commercially prepared canvas is gray-tinted or too meagerly coated; lead copal ground will make a brilliantly white and flexible surface for it.

INGREDIENTS	PARTS
Oil-copal solution (Varnish No. 7)	3
White lead, dry pigment	5

DIRECTIONS FOR MANUFACTURE: Measure the two materials, in separate mounds, onto thick plate glass or a marble slab. Using either a strong palette knife or a muller, grind small quantities together until they are smooth and lump free. Continue this procedure until all the material has been ground smooth.

DIRECTIONS FOR USE: Stretch the commercial canvas taut and spread the copal-lead ground onto it with a palette knife, laying it on as thinly and smoothly as possible. All irregularities must be removed while the ground is wet and fresh, for they cannot be altered upon hardening. If the ground is not sufficiently opaque and white, apply a second coat after three weeks; allow it to dry until the surface is hard before you paint on it. Medium No. 18 is excellent for use with paint over this ground.

Umber and white lead ground for canvas

PURPOSE: For a rapid curing, dark tinted ground, the addition of umber and a filler will provide an excellent solution.

INGREDIENTS	PARTS
China clay	8
Raw umber	2
White lead, dry pigment	5
Raw linseed oil	4

DIRECTIONS FOR MANUFACTURE: Make two batches from this recipe: one for the first coat, and another for the second. For the first coat, grind together all the clay with $1\frac{1}{2}$ parts of the umber and $2\frac{1}{2}$ parts of oil; scrub this combination thinly onto the stretched canvas. The remaining ingredients will constitute the second coat.

DIRECTIONS FOR USE: Use a fine, knot-free linen canvas. After the first thin coat has been allowed a week to dry, remove any knots or imperfections with a razor blade or scalpel. Although the second coat will be lighter in color, the resulting ground will be a medium, warm gray. Even though this ground is fast drying, it should not be painted on for several weeks—the longer the better. Dark grounds—which invite bold colors and values— require that the paint be heavily applied to prevent later darkening, as oil paint grows translucent with age.

Toned oil ground for canvas

PURPOSE: This two-part, umber tinted ground dries rapidly and gives a medium value base for color development.

INGREDIENTS	PARTS
China clay	9
Raw umber, dry pigment	2
Linseed oil	2
White lead, dry pigment	20
Raw umber, dry pigment	1
Linseed oil	4

DIRECTIONS FOR MANUFACTURE: Using a palette knife, grind the first group of ingredients together until no lumps are evident. The amount of oil may seem insufficient at first, but continued working with the palette knife will insure a smooth, oily paste. The second group of ingredients can be ground and stored for application the same week, or applied after three weeks or more.

DIRECTIONS FOR USE: With the first batch, add a little turpentine to make the paste thin as cream; with a brush, stipple the material into the fibers of a stretched and sized canvas. A second coat, with less turpentine, can be applied after a day. When it is time to use the second batch, apply the undiluted mixture with a palette knife to make a thin, smooth, uniform coating. Allow the canvas to dry two or three months before painting.

Lead and oil for canvas

PURPOSE: Lead white and stand oil are the traditional materials used to achieve a permanent, low oil content, yet flexible ground.

INGREDIENTS	PARTS
White lead, dry pigment	*10*
Barium white, dry pigment	*1*
Stand oil	*2*
Turpentine	*1*

DIRECTIONS FOR MANUFACTURE: On a glass slab, combine the two dry pigments and add a little stand oil to a small portion of the dry pigment. Continue grinding with the palette knife in small batches, putting each portion aside until all the material is used. Wetting the dry pigment with a little turpentine helps carry out the process. This formula makes a very stiff paste.

DIRECTIONS FOR USE: For the first coats on a sized, stretched canvas, dilute the paste with turpentine so it can be stippled on with a brush. After a week, stipple on a second coat, using less turpentine; use a palette knife to apply the third coat unthinned. Three weeks' drying time is recommended between the second and last coats. Paint on this ground after it has dried several months.

Oil and glue emulsion for canvas

PURPOSE: Oil and glue emulsion creates a very fast setting ground which produces a smooth, drum-tight surface.

INGREDIENTS	PARTS
Hide glue solution (Size No. 1 or Paint No. 28)	1
Zinc or lead white, dry pigment	1
Chalk	1
Stand oil, heavy body	2

DIRECTIONS FOR MANUFACTURE: In small amounts, grind the combined dry pigments into the warm glue solution until a smooth glue and pigment solution is achieved. Stir the stand oil—in a thin, intermittent stream—into the nearly cool glue solution. Add enough ammonium bicarbonate solution to insure complete emulsification.

DIRECTIONS FOR USE: Apply the emulsion to a sized, untempered Masonite panel, using a palette knife or a stiff brush to make a very thin first coat. Apply the second coat after a week, and a third after three weeks' drying of the second coat. This method produces a relatively thin, slightly cream-colored ground, excellent for painting with oil or tempera.

Half oil for canvas

PURPOSE: The combination of glue gesso and oil makes a very rapid drying ground; four coats produce a luminous, white, matte surface.

INGREDIENTS	PARTS
Chalk ground (Ground No. 8)	2
Stand oil, heavy body	1

DIRECTIONS FOR MANUFACTURE: Follow directions for Ground No. 8. When the ground is just warmed to a liquid state, add the stand oil slowly, stirring constantly. Don't stir in air bubbles, but do stir vigorously enough to break up the oil into a smooth, homogeneous mixture with the chalk ground solution.

DIRECTIONS FOR USE: Use a brush to apply the thick, creamy ground onto a glue-sized, untempered Masonite panel; let the ground dry a day or two before warming the solution and applying a second coat. Allow a week's drying time between the third and fourth coats, and another week or two before painting on this ground with oil, casein, or egg tempera.

Gesso and oil for canvas or panel

PURPOSE: For making a satin-smooth, absorbent, flexible ground, the combination of a glue gesso and oil serves perfectly.

INGREDIENTS	PARTS
Chalk ground (Ground No. 8)	*3*
Raw linseed oil	*1*

DIRECTIONS FOR MANUFACTURE: Complete the making of Ground No. 8. While it is barely warm enough to be liquid, slowly add the oil, stirring vigorously. Try to stir without breaking the surface of the solution or adding air bubbles. Let it stand for a few minutes, then apply.

DIRECTIONS FOR USE: Brush the slightly warmed solution onto a glue-sized panel or a stretched canvas, and let it dry a week before you apply a second coat. A week later, apply the third coat and let it dry two or three weeks before sanding the surface with No. 220 garnet paper. Holding the surface tilted at an angle to direct sunlight will expose any irregularities; these can be removed with the garnet paper. Excellent for egg tempera and gouache, this ground is too absorbent for oil paint without first isolating the ground.

Chalk ground (gesso) for panels

PURPOSE: To achieve an ivory-smooth, brilliant white surface, no other formula equals traditional glue gesso. It is ideal for egg tempera or for meticulous rendering in oils.

INGREDIENTS	PARTS
Whiting, gypsum, or *chalk*	1
Zinc white, dry pigment	1
Hide glue solution (Size No. 3)	1

DIRECTIONS FOR MANUFACTURE: Blend the dry pigments together in an enameled pan, and add a small amount of the warmed glue solution; work out the lumps before you add more glue. You can avoid working in air bubbles by keeping the glue solution only warm enough to remain liquid—instead of hot. Let the finished gesso stand, warm, for half an hour before using.

DIRECTIONS FOR USE: Liberally brush alcohol over the smooth side and edges of untempered Masonite panels and let them dry. Then brush the warm gesso solution onto the panels in one direction without working over with further brushstrokes. After the coat becomes dull, apply subsequent coats in opposite directions, alternately—as many as five for a brilliant surface. Allow them to dry for two days, then finish with No. 220 garnet paper; or rub the panel with a ball of dampened old white linen for an ivory surface—a procedure requiring practice, but worth the effort.

Gesso for panels (hide glue solution)

PURPOSE: The ancient, traditional recipe for gesso given below involves quite a bit of bother; however, it gives a velvety smooth gesso solution and works very well.

INGREDIENTS	PARTS
Plaster of Paris cakes	2
Hide glue solution (Size No. 3)	1

DIRECTIONS FOR MANUFACTURE: Sprinkle the powdered plaster of Paris into eight times its volume of water; stir constantly for 15 minutes, then intermittently for a couple of hours. Cover and leave this solution for a month, stirring it whenever you remember to do so. After a month, pour off the excess water and deposit the plaster in a piece of white sheeting. Squeeze out the water, form little cakes of plaster, and let them dry. Add these cakes to the warm glue solution and stir to a smooth mixture.

DIRECTIONS FOR USE: Prepare untempered Masonite panels by brushing the smooth surface with alcohol and allowing them to dry. Size them and allow to dry. Then brush the warm gesso solution onto them in five coats, alternating the directions of the coats and letting each dry until dull before you apply the next. Finish with No. 220 garnet paper or rub with a ball of dampened white linen.

Gesso for panels (gelatine solution)

PURPOSE: To make the traditional brilliant white gesso for rigid panels, gelatine size solution permits more rapid preparation and gives the smooth surface required for egg tempera.

INGREDIENTS	PARTS
Gelatine solution (Size No. 1)	*6*
Whiting	*10*

DIRECTIONS FOR MANUFACTURE: Prepare the gelatine solution according to instructions; while it is still warm and liquid, sprinkle the whiting onto the surface. Stir gently to prevent the formation of air bubbles; after all the whiting has been absorbed, strain the mixture through two layers of cheesecloth into a clean enameled pan.

DIRECTIONS FOR USE: While the size is warm, coat the Masonite panels or well cured plywood and let them dry. Apply the warm gesso solution by brushing each coat in one direction, changing directions with alternate coats. After five or more coats have been applied, finish the surface by sanding it with No. 220 garnet paper or by rubbing the surface ivory-smooth with a ball of dampened white linen.

Casein gesso for panels and canvas

PURPOSE: Casein gesso provides a very white and tough surface for any kind of paint, but particularly for casein paints.

INGREDIENTS	PARTS
Casein solution (Size No. 4)	9
Whiting	4
Zinc white, dry pigment	4

DIRECTIONS FOR MANUFACTURE: Mix the dry pigments together thoroughly and add them slowly to the prepared casein solution. Strain this mixture through two layers of cheesecloth into a clean vessel.

DIRECTIONS FOR USE: Use unsized, untempered Masonite panels, or size them first with casein solution. Do not size with hide glue solution. Apply the gesso in thin coats with a brush, letting each coat dry for a half-hour or more, until four or five coats have been applied. Let the last coat dry overnight before sanding it lightly with No. 220 garnet paper. Be sure to stir the gesso frequently, for the pigment tends to settle rapidly.

Casein gesso on commercial canvas

PURPOSE: If you plan to paint on a gesso-coated canvas, it is wise to buy the readily available, prepared commercial canvas and to gesso the raw side. The commercial oil ground already on the canvas provides an excellent protective backing, and casein gesso gives a tough painting surface.

INGREDIENTS

Casein gesso (Ground No. 11)

DIRECTIONS FOR MANUFACTURE: Follow the instructions given for preparing Ground No. 11.

DIRECTIONS FOR USE: The first method is to tack a commercially oil-grounded canvas face down (ground side down) onto a drawing board. Cover the raw canvas surface with two coats of casein gesso, letting each coat dry for half an hour. Remove the canvas and mount it—casein side up—to a rigid plywood or Masonite panel, using a wax-resin adhesive (Adhesive Nos. 1 and 6). Use any kind of paint on this gesso.

The second method is to stretch a commercially prepared canvas with the raw canvas side facing out and apply two coats of casein gesso to the raw surface. The commercial ground on the back provides protection from moisture and mold.

Commercial casein for panels

PURPOSE: Commercially prepared casein white paint can be used where large, rigid wall surfaces must be given a fresh ground to receive paint which is not intended to last several centuries.

INGREDIENTS

Any good commercial brand of casein white paint

DIRECTIONS FOR MANUFACTURE: None. All the work has been done for you.

DIRECTIONS FOR USE: Make sure the surface is scrubbed free of dirt and grease; then brush the white casein paint over it. One coat should suffice, but you may apply another if the first does not cover the surface well. After the casein white has dried overnight, apply casein, oil, or wax paints to it. This same treatment may be given to any rigid panel, but this ground should not be used for cloth or flexible supports because casein is relatively brittle and does not withstand flexing.

Casein gesso for panels

PURPOSE: If you are isolated from sources that supply powdered casein, or if you enjoy engaging in an ancient miracle, this formula will provide you with a very tough gesso.

INGREDIENTS	PARTS
Dry curd cottage cheese	6
Lime putty (Size No. 11)	1
Water	7
Zinc white and whiting, dry (1 to 1)	14

DIRECTIONS FOR MANUFACTURE: Make the lime putty, combining only the thick putty with the cottage cheese. Any prepared cottage cheese will serve, but dry curds make by far the strongest gesso. After a few hours, the lumps of cheese dissolve into the lime putty, producing a strong casein solution. Grind the dry pigments together with a little water to make a lump free paste; stir in the casein solution and then the remaining water.

DIRECTIONS FOR USE: Apply the gesso to unsized, untempered Masonite or to thoroughly cured (one year) plywood or wooden walls. Two or three thin coats produce an excellent surface for painting with casein, glue, oil, or wax paints.

Starch ground for pastels

PURPOSE: Starch paste provides a cheap and simple means of making the surface of paper sheets or boards sufficiently toothy to hold pastel firmly.

INGREDIENTS

Starch solution (Size No. 7)
Powdered pumice

DIRECTIONS FOR MANUFACTURE: Follow the directions given for making Size No. 7, taking care not to burn or scorch the paste; a double boiler is a little slower, but it insures a perfect material.

DIRECTIONS FOR USE: Mount paper, canvas, or cardboard on a rigid surface. To mount paper for this purpose, sponge the paper, glue down the edges with brown paper tape, and let it dry. Apply the starch paste evenly and quickly to the paper, using a sponge or your hand to insure smoothness and freedom from irregularities; then liberally sprinkle powdered pumice over the surface, covering it completely. Let it dry, then brush off the excess pumice. If you want any color in the ground, add it to the paste before applying.

Oil, resin, wax for stone, terra cotta, slate

PURPOSE: Stone, ceramics, or slate which are to be painted or decorated, frequently require a firm, white ground. This formula also helps protect the base from weathering.

INGREDIENTS	PARTS
Size No. 12	2
White lead, dry pigment	1

DIRECTIONS FOR MANUFACTURE: Use the size solution at room temperature (a solid paste) or warm it slightly to a liquid state. After moistening the pigment with a little turpentine, work the dry pigment with a palette knife into a stiff paste; then work the pigment and size together until the pigment is finely dispersed.

DIRECTIONS FOR USE: Warm the stone to room temperature. The warmer it is, the more easily the ground can be applied. Warm the ground to liquid-paste and brush it onto the stone (already sized with Size No. 12). This ground dries to a tough, white coat which accepts oil and wax paints. An excellent paint can be made by combining Size No. 12 with dry pigments.

Plaster for fresco

PURPOSE: A brilliant white, slightly sparkling finish of lime plaster, expertly applied to the dampened brown undercoat (or *scratch coat*), gives a flawless surface for fresco painting.

INGREDIENTS	PARTS
Lime putty (Size No. 11)	*6*
Whiting	*1*
Marble dust	*2*

DIRECTIONS FOR MANUFACTURE: Combine the whiting and marble dust and mix them thoroughly. Add these to the lime putty and stir or mix together until the plaster is lump free and plastic.

DIRECTIONS FOR USE: Wet down the plaster undercoat, and trowel on the above mixture—it can be troweled perfectly smooth. Apply this mixture to only as large an area as you intend to paint and complete within an hour or two. Wait until the surface moisture has drawn in before you paint with lime proof pigments mixed with water. Don't try to work over with successive brushstrokes, for the brush will pick up the plaster and dull the colors.

Plaster of Paris for painted relief

PURPOSE: This formula serves not only as a ground, but also as a support. A slab of dry plaster of Paris is wonderfully easy to carve, permitting the artist to cut reliefs upon which he may paint.

INGREDIENTS	PARTS
Plaster of Paris	5
Water	2

DIRECTIONS FOR MANUFACTURE: Continually stirring, sprinkle the plaster into the water. Take care to avoid splashing or causing bubbles. This ratio produces a creamy consistency; all lumps should be dissipated during the stirring. Don't dawdle at the task, for the plaster begins quickly to thicken.

DIRECTIONS FOR USE: Pour half of the plaster into a form—really a shallow box—constructed of two-by-fours and Masonite. Place a metal mesh in the plaster, then complete the pouring. For later hanging or attaching purposes, wires can be left standing free, having been threaded through the metal mesh before this mesh is laid onto the wet plaster and surrounded. Carve the plaster while it is soft and damp—which it will be for many days— then paint it with any of the encaustic formulas (see Mediums No. 22 and 23) or with Paint No. 4 after the plaster has dried thoroughly.

Paints

Oil and balsam

PURPOSE: Where thin overpainting is to be applied to an underpainting of casein or over a fixed drawing, balsam and oil give an excellent, medium-fast drying vehicle.

INGREDIENTS	PARTS
Sun thickened linseed oil	*1*
Venice turpentine	*1*
Turpentine	*1*

DIRECTIONS FOR MANUFACTURE: Combine and stir together all the ingredients.

DIRECTIONS FOR USE: On a glass palette or marble slab, measure out only the amount of pigments you expect to use within a day or two. Add the mixture drop by drop, grinding with the pigment thoroughly before adding more of the solution. Since grinding tends to make paint more liquid, use only as much solution as will produce a fairly thick mixture with the pigments. The solution can also be used as a medium with tube oil paint or as a final varnish.

Oil and copal resin

PURPOSE: Where it is desirable to maintain a workable, slow drying paint surface, this combination serves without sacrificing the toughness for which copal resins are noted.

INGREDIENTS	PARTS
Oil-copal solution (Varnish No. 7)	1
Raw linseed oil	2

DIRECTIONS FOR MANUFACTURE: Combine the ingredients at room temperature.

DIRECTIONS FOR USE: Grind this mixture together with dry pigments; make up only as much paint as you intend to use immediately or for a short period. This vehicle dries in about three days, but the drying time can be accelerated by adding no more than 24 drops of cobalt linoleate drier to each half pint of solution. Such fast drying paint should be employed on only the first layers; subsequent painting should be carried out without the use of drier. The substitution of sun thickened linseed oil or stand oil for the raw linseed oil will make a faster drying paint.

Balsam and sun thickened oil

PURPOSE: Venice turpentine, like other balsams, gives high moisture resistance to paint vehicles. Used heavily, it is slow drying, but thin layers dry rapidly.

INGREDIENTS	PARTS
Venice turpentine	*2*
Sun thickened linseed oil	*1*

DIRECTIONS FOR MANUFACTURE: True Venice turpentine is a very heavy, viscous liquid. Art supply houses furnish the best quality, but other suppliers, who sell in bulk, often merchandise Venice turpentine in which crystals form. In the latter case, just decant the clear liquid, which will serve very well. Warm the ingredients together over heat or in a capped bottle placed in the sunshine.

DIRECTIONS FOR USE: Grind this mixture with dry pigments, using only enough to make up a quantity which will be used within a day or two. Thinned with turpentine and painted on in thin layers, this paint will dry rapidly to a high gloss. Thickly ground and thickly painted, this paint will require two or three days to dry.

Resin and wax for plaster, slate, or stone

PURPOSE: This vehicle combines the toughness of oil, the hardness of copal, and the water-resistance of paraffin or ceresin. The mixture can be used as a size similar to Size No. 12, or simply as a varnish coating to protect the support from weathering.

INGREDIENTS	PARTS
Oil-copal solution (Varnish No. 7)	*4*
Paraffin or ceresin	*1*
Turpentine	*3*

DIRECTIONS FOR MANUFACTURE: Combine and heat the ingredients over a flame-free unit until the wax has melted into solution with the other materials.

DIRECTIONS FOR USE: When the solution cools, it becomes a soft paste. Grind this paste with dry pigments and use it for encaustic painting, applying heat to melt the surface; or apply the paint, warmed, to the warm support (plaster, stone, or slate). Thinned with turpentine, this paint can be used on other supports such as canvas or panels, or it can be used as a medium with tube oil paint.

Wax and water emulsion

PURPOSE: When you want a water-paint that combines the expediency and handling quality of an aqueous medium with the permanence of wax painting, this simple formula works well.

INGREDIENTS

Beeswax-water emulsion (Varnish No. 24)
Dry pigments

DIRECTIONS FOR MANUFACTURE: Follow the directions carefully when you make the beeswax-water emulsion, for emulsions are sometimes tricky affairs. Once made, however, this emulsion remains stable and stores perfectly at room temperature.

DIRECTIONS FOR USE: Make a stiff paste of the water and the dry pigments, and combine with the emulsion. Some pigments can be combined simply by using a bristle painting brush; others require the use of a palette knife to make the pigment fine enough. For outdoor color sketching, little jars of prepared pigments, a jar of water, and some bristle brushes are convenient for painting on paper, cardboard, or canvas. When the paint has dried thoroughly, rub it to a soft luster with a dry cloth.

Beeswax for encaustic

PURPOSE: Beeswax is universally employed for all-around use, mixed with tube paints, with pigments, or alone as a protective coat for finished works.

INGREDIENTS	PARTS
Beeswax	*1*
Turpentine	*3*

DIRECTIONS FOR MANUFACTURE: Combine and heat the ingredients (not over open flame) until the wax has melted. Stir while the solution cools to a very soft paste.

DIRECTIONS FOR USE: Mix the paste with dry pigments—taking pains to grind the pigment thoroughly into the wax—and apply this paint to a rigid panel with a brush or palette knife. With experience, you will learn that certain colors, such as white, melt much more slowly than deeper ones, and give you the opportunity to achieve unusual effects by laying light colors over darks and heating to disperse the lights. Paint can be melted by applying direct flame or by using a heat lamp. Direct flame often ignites the paint, but a lusty puff of breath extinguishes the fire. Tube oil paint may be used with this paste, but requires a longer drying time.

Wax and resin paste for encaustic

PURPOSE: Elemi resin is extremely sticky and combines with beeswax to provide a fast drying, tough material which can also be used as a painting medium.

INGREDIENTS	PARTS
Elemi resin, soft	1
Beeswax	1
Oil of spike lavender	1
Turpentine	1

DIRECTIONS FOR MANUFACTURE: Heat all the ingredients together—but not over an open flame; when the wax and resin have melted, remove from the heat and stir as the solution cools.

DIRECTIONS FOR USE: This formula makes a soft, sweet smelling paste which can be ground with dry pigments and applied to a rigid panel for encaustic techniques; or it can be used with tube oil colors for encaustic. Diluting the paste with turpentine or oil of spike lavender permits the mixture to be used with tube colors on canvas. Oil of spike lavender evaporates a bit more slowly than does turpentine and has a much more fragrant odor. A thin coat of this paste will dry within three hours.

Wax and damar resin for encaustic

PURPOSE: To make a harder, tougher paint than beeswax alone will provide, add damar resin. This ingredient is clear and fast-drying.

INGREDIENTS	PARTS
Beeswax	2
Damar varnish (Varnish No. 1)	4
Turpentine	1

DIRECTIONS FOR MANUFACTURE: Combine all the ingredients and heat (not over open flame) until the wax has melted into the solution. Remove from the heat and stir until the solution cools to a paste.

DIRECTIONS FOR USE: Grind the paste with dry pigments or with tube oil colors; apply to panels with a brush or palette knife. For encaustic technique, heat the paint with a direct flame or a heat lamp. Diluted with turpentine, this paste may be used with tube oil color for ordinary painting techniques; the resin and wax thicken the oil paint, enabling you to form thick impastos. A thin coat of this paste dries in half an hour.

Wax, damar resin, oil for encaustic

PURPOSE: Dry storage of encaustic material is sometimes a great advantage. This formula, with oil added to give it toughness, provides an easily handled, dry, hard cake.

INGREDIENTS	PARTS
Beeswax	*8*
Damar Varnish (Varnish No. 1)	*1*
Sun thickened linseed oil	*1*

DIRECTIONS FOR MANUFACTURE: Combine all the ingredients and melt them together in a pan, stirring to mix thoroughly. Take a sheet of aluminum foil —the heavy stock made for broiling is best—and fold the edges to a double thickness to form a shallow pan. When the mixture is melted and hot, pour it into this pan to cool. When hard, remove the mixture from the foil and break into convenient sizes for storage or use.

DIRECTIONS FOR USE: For encaustic technique, reheat and melt this material, grind in the dry pigments, and apply to a rigid panel with a knife. To use in paste form, melt the pieces with an equal quantity of turpentine. Thinned sufficiently this will make a painting medium for use with tube oil paints.

Wax blend for encaustic

PURPOSE: Natural waxes alone, with no resins or oils added, give a tough and hard finish that will take a very high polish.

INGREDIENTS	PARTS
Hard wax (carnauba or candelilla)	*1*
Soft wax (beeswax, montan, or ceresin)	*3*

DIRECTIONS FOR MANUFACTURE: Melt the ingredients together and stir to combine well. Form a pan as instructed in Paint No. 9, for this formula also produces a solid. Candelilla, a Mexican plant wax, is nearly as hard as carnauba, but is much darker in color. Bleached montan is yellow; ceresin may be purchased in clear white.

DIRECTIONS FOR USE: Melt the wax and grind it with dry pigments. It is convenient to keep these paints in a metal muffin tin, which can be placed over a controlled heat hotplate, and from which the colors may be extracted and applied with a painting knife to rigid panels. Reheat the mixture on the panel, using direct flame or a heat lamp. Like other hard materials, this wax can be made into a paste by melting it with turpentine. In this form, the wax makes an excellent final varnish.

Wax and copal resin for encaustic

PURPOSE: Hard copal resin combines with wax
and oil in an easily made formula which serves as
a medium or final varnish.

INGREDIENTS	PARTS
Oil-copal varnish (Varnish No. 7)	*1*
Beeswax	*1*
Oil of spike and/or turpentine	*2*

DIRECTIONS FOR MANUFACTURE: Combine all the
ingredients and heat (not over an open flame) until
the wax has melted. Remove from the heat and
stir until the mixture cools to a soft paste.

DIRECTIONS FOR USE: To paint an encaustic on a
rigid panel, grind the dry pigments with the mixture
and apply with either a brush or a palette knife.
Melt the paint on the panel with either a direct
flame or with a heat lamp. Tube oil colors work well
with this paste and may be used for either encaustic
or regular painting. For use as a final varnish,
dilute the paste with turpentine to insure a thin coat.

Wax and damar resin for encaustic

PURPOSE: This formula of damar and wax makes a hard, dry blend that stores easily and can be diluted for other uses.

INGREDIENTS	PARTS
Beeswax	2
Damar, dry lumps	1

DIRECTIONS FOR MANUFACTURE: Melt the damar first, then add the wax, and heat together until the wax has melted. Blend by stirring, then pour into an aluminum foil pan (described in Paint No. 9) to cool and harden. Score and break into pieces of convenient size for storage and use.

DIRECTIONS FOR USE: This material handles like Paints No. 9 and 10; it must be reheated and melted in order to grind it with dry pigments or to combine it with tube oil paint. Apply this paint to rigid panels, using torch, heat lamp, or heated metal instruments to manipulate the wax colors. Further dilution with turpentine permits this material to be used as a painting medium or final picture varnish.

Wax and gum emulsion

PURPOSE: Gums and glues give fresh handling and quick drying qualities ideal for underpainting or color sketching. Wax adds permanence and body.

INGREDIENTS	PARTS
Beeswax solution (Varnish No. 21)	6
Gum solution (Paint No. 36 or 38)	4
Ammonium carbonate	1

DIRECTIONS FOR MANUFACTURE: For most emulsions, ammonium carbonate insures certain results, so it is a good idea to crush a few lumps of this material into warm water to keep on hand. Heat the gum solution in a double boiler, and alternate between stirring in wax solution and small quantities of ammonium solution. When all the ingredients have been added, continue stirring until the effervescence stops. Remove from the heat and stir until cool. Keep the emulsion under refrigeration to prevent spoilage.

DIRECTIONS FOR USE: Mix only the amount you need for each painting session. Grind the dry pigments with water, and combine with the emulsion on the palette. Excellent for painting on heavy paper or cardboard with bristle brushes, this emulsion sets instantly.

Egg tempera

PURPOSE: Egg yolk, mixed with water, is one of the most ancient, permanent, and pleasant water-miscible paints. It dries almost instantly.

INGREDIENTS	PARTS
Egg yolk	*1*
Water	*1*

DIRECTIONS FOR MANUFACTURE: Separate the yolk from the white, discarding the white and placing the yolk in your palm. Pass the yolk gently from one palm to the other, drying the empty palm. When the yolk sac becomes fairly dry, pick up the yolk with your thumb and forefinger and hold it over a clean, small jar. Puncture the yolk and drain it into the the jar; add water and shake into a pale emulsion.

DIRECTIONS FOR USE: Deposit small quantities of dry pigments into the wells of a porcelain specimen plate. Use an eye dropper to add water and/or alcohol to each well, and grind with a glass rod. Use a No. 1 or No. 2 pointed round sable brush for traditional cross-hatching technique, adding enough yolk-water to cause a color stroke to dry with luster. Paint over glue gesso applied to a rigid panel.

Egg, resin, oil emulsion

PURPOSE: To make a *thixotropic*—or impasto-like—
paint, a combination of oils, resins, and egg yolk
makes a good formula. This emulsion may be diluted
with water.

INGREDIENTS	PARTS
Egg yolk	*1*
Any oil or varnish	*1*
Water	*1 or more*

DIRECTIONS FOR MANUFACTURE: Separate the yolk
and discard the white as described in Paint No. 14.
Stir the oil or resin into the egg yolk drop by drop,
using a paint knife to work the yolk vigorously.
Add the water last, in the same fashion.

DIRECTIONS FOR USE: This emulsion can be used
with dry pigments. First, make a smooth, stiff paste
of the pigments and water. On the palette, grind
the color paste into the emulsion. Make up only
as much as you need for one painting session.
Thinned with water, this formula is good for an
underpainting which will be covered with oil or
resin paints. It is fast setting and quick drying.
For a thick emulsion use oils; and for a thin emulsion,
use resin varnishes.

Egg and stand oil emulsion

PURPOSE: The clarity and fast drying of Dutch stand oil make it particularly suited to join with egg for a thick emulsion paint that sets rapidly.

INGREDIENTS	PARTS
Egg yolk	1
Dutch stand oil	1

DIRECTIONS FOR MANUFACTURE: Separate the yolk and discard the white as described in Paint No. 14. Work the yolk on a glass palette, adding the oil drop by drop. This formula makes a very thick emulsion.

DIRECTIONS FOR USE: Undiluted, this emulsion may be used with tube oil paint to make it thick without danger of cracking; the more heavily pigmented, the better it works. For painting in general, however, this emulsion serves best ground with dry pigments and then diluted with water. To stiffen white oil tube paint, first grind the emulsion with white dry pigment, then grind in the tube paint.

Egg, stand oil, water emulsion

PURPOSE: Egg-oil emulsion produces a non-dripping paint which permits the finest, most detailed brushwork in a wet oil painting.

INGREDIENTS	PARTS
Egg yolk	*2*
Stand oil, heavy	*1*
Water	*3*

DIRECTIONS FOR MANUFACTURE: Separate the yolk from the white as described in Paint No. 14 and deposit the yolk in a small jar. Pour the oil into the yolk in a very thin stream, continuously stirring until the oil has been used up. Add the water in the same fashion. Egg yolk, which already contains oil, is a natural emulsion, and thus insures the easy addition of oil and water.

DIRECTIONS FOR USE: Grind the dry pigments into this emulsion and paint directly on gesso panels or on primed canvas, diluting the paint with water as desired. Undercoats should be quite thin. Subsequent coats may be applied unthinned. This is an excellent paint for adding fine detail on wet oil paint, for it sets immediately without running, yet is permanently bonded to the wet oil.

Egg and damar resin emulsion

PURPOSE: This emulsion combines the virtues of quick drying damar and quick drying egg to form a tough paint coat which bonds with oil or tempera. Dilute this paint with turpentine.

INGREDIENTS	PARTS
Egg yolk	*1*
Damar varnish (Varnish No. 1)	*2*

DIRECTIONS FOR MANUFACTURE: Follow the directions given in Paint No. 14 for separating the egg yolk and draining it into a small jar, then stir the egg yolk drop by drop into the varnish until it has all been smoothly absorbed.

DIRECTIONS FOR USE: While oil-egg formulas produce a fairly thick emulsion, resin varnishes with egg make thin emulsions. The above proportions require dilution with turpentine rather than with water. Grind the dry pigments into the emulsion and paint on gesso panels or on canvas; or use this paint for fine detailing, wet-in-wet on oil paint.

Egg and oil emulsion

PURPOSE: While the nature of pure egg tempera discourages any attempt to soften or fuse colors, and demands rigid panel supports for the best effects, this modified formula partakes a little of the characteristics of oil paint.

INGREDIENTS	PARTS
Egg yolk	1
Oil of spike lavender	10 drops
Raw linseed oil	1
Water	1

DIRECTIONS FOR MANUFACTURE: Separate the yolk from the white, discard the white, and drain the pure yolk into a small jar. Drop by drop, vigorously stir the fragrant oil of spike lavender into the yolk until all is incorporated. In the same fashion, add first the linseed oil, then the water.

DIRECTIONS FOR USE: Apply this paint either to gesso panels or to primed canvas. Grind the dry pigments—only as much as you will need for one painting session—into the emulsion, using either a paint knife or palette knife. Dilute with water for thin undercoat layers, reducing the use of water in subsequent layers of paint. This emulsion can also be used to paint wet-in-wet into fresh oil paint.

Egg, oil, vinegar emulsion

PURPOSE: If you have difficulty separating eggs, this formula saves you the trouble. Paint No. 20 resembles traditional egg-oil emulsions in every other respect.

INGREDIENTS	PARTS
Whole egg	1
Raw linseed oil	1 teaspoon
Vinegar	4 drops

DIRECTIONS FOR MANUFACTURE: Break the egg and drop the contents into a small, clean jar. Add the oil, cap the jar, and shake the contents until they combine completely. Add vinegar last as a preservative to help prevent fast spoilage. Strain the whole mixture through two layers of cheesecloth into a fresh jar.

DIRECTIONS FOR USE: This emulsion produces a paint which can be thinned or diluted with water, and which is slightly less oily than other egg-oil emulsions. Grind pigment paste into the emulsion, using only as much pigment as you need for one painting session. This paint can be used directly on gesso panels or on canvases, and to paint wet-in-wet on fresh oil paint.

Egg, stand oil, damar resin emulsion

PURPOSE: An emulsion which embodies all the virtues imaginable simply includes egg, oil, and resin. The basic proportions, however, are similar to other egg-oil emulsions.

INGREDIENTS	PARTS
Egg yolk	6
Stand oil, heavy	2
Damar varnish (Varnish No. 1)	2
Water	3

DIRECTIONS FOR MANUFACTURE: Follow the directions for separating and draining egg yolk given in Paint No. 14. Combine the oil and varnish, then stir them into the egg yolk, drop by drop, until the emulsion is complete. Add the water last in the same fashion.

DIRECTIONS FOR USE: This formula can be used for direct painting on a panel or canvas, or for overpainting a casein or glue-tempera underpainting. Grind the emulsion with dry pigments (already ground into a water paste), using only as much pigment as necessary to complete one painting session. This formula can be painted wet-in-wet into fresh oil paint.

Egg, oil, copal resin emulsion

PURPOSE: Similar to Paint No. 21, this formula juggles its ingredients to give time for more fusing of tones by slowing down the drying time.

INGREDIENTS	PARTS
Egg yolk	*4*
Raw linseed oil	*3*
Oil-copal solution (Varnish No. 7)	*1*
Oil of spike lavender	*10 drops per yolk*

DIRECTIONS FOR MANUFACTURE: Follow the directions given in Paint No. 14 for separating egg yolk, then, drop by drop, stir the oil of spike lavender into the yolk until combined. Mix the oil and varnish thoroughly and stir into the egg, adding only a little at a time, until the finished emulsion is achieved.

DIRECTIONS FOR USE: This emulsion can be diluted with water. Grind in only as much dry pigment as you need for one painting session, and apply this paint to gesso panels or canvas. This formula also serves well for painting over an egg or glue underpainting, and for painting wet-in-wet into oil paint.

Whole egg and damar resin emulsion

PURPOSE: A little damar resin helps toughen egg film during its tender early months. After it has completely polymerized, egg becomes one of the toughest, most insoluble substances known.

INGREDIENTS	PARTS
Whole egg	*4*
Damar varnish (Varnish No. 1)	*1*
Water	*12*
Oil of cloves	*20 drops*

DIRECTIONS FOR MANUFACTURE: Take a pint jar and break the egg into it; cap the jar and shake it until the egg is mixed. Add the varnish to the contents and repeat the process; then add the oil of cloves, and finally add the water. After shaking thoroughly, strain the emulsion through two layers of cheesecloth into another jar. One egg makes about one half pint of emulsion.

DIRECTIONS FOR USE: With a painting knife or a palette knife, grind as much dry pigment as you need for one painting session. As you paint, combine the pigment paste with more emulsion. Paint on a gesso panel or on canvas. Egg-resin also makes an excellent underpainting vehicle.

Glair (egg white)

PURPOSE: Medieval artists needed very delicate paint to illuminate parchment. *Glair* means *clear*; this substance is transparent.

INGREDIENTS

White of egg

DIRECTIONS FOR MANUFACTURE: Making glair is rather a fun project if you like to whip egg whites. Use either a kitchen fork or a wire whisk. Place the egg white on a platter and beat until the froth becomes dry. Despite the apparent conversion of egg white into dry froth, you will find a small amount of liquid at the bottom; pour this into a little jar, for it is the glair. Or, after beating, put the froth into a paint jar, mix in four tablespoons of water, and decant the liquid after eight hours. The first method yields a viscous medium; the second produces a fluid medium.

DIRECTIONS FOR USE: Traditionally, the best glair was mellowed by a few days of aging, but it serves quite well in its fresh state. Grind dry pigments with water to form as much color paste as you need; be sure to grind well, for this paint is similar to watercolor and needs fine pigment particles. Dip a fine sable brush into glair and pigment to paint on parchment and paper; use it to add tiny details wet-in-wet on oil paint.

Egg and lime water emulsion

PURPOSE: For painting fresco-secco on outdoor walls which are protected from direct weathering, combine egg with lime water.

INGREDIENTS	PARTS
Egg yolk	1
Lime water (Size No. 11)	1

DIRECTIONS FOR MANUFACTURE: Follow the directions given in Paint No. 14 for separating egg; then make the lime water according to the directions given in Size No. 11. Combine the ingredients in a jar and shake together. Dilute this emulsion with lime water instead of with plain water.

DIRECTIONS FOR USE: Wet down an old plaster wall with lime water (Size No. 11) and let dry. Grind your dry pigments with lime water into a thick paste; use lime-proof pigments. Use the fresco technique of cross-hatching color strokes and paint on the sized wall. This emulsion may also be used in true fresco and painted into fresh lime plaster.

Glue emulsion

PURPOSE: Animal glues, emulsified with oils or resins, provide strength and permanence for color sketching or for quick drying paint for under-painting.

INGREDIENTS	PARTS
Hide glue solution (Paint No. 28 or Size No. 1)	
or	
Gelatine solution (Size No. 1)	*1*
Oil or resin	*2*

DIRECTIONS FOR MANUFACTURE: Into the barely liquid glue or gelatine solution, stir your selection of oil and/or resin solutions, drop by drop. You must stir vigorously to insure emulsification. If necessary, add either ammonium carbonate or household ammonia to effect the emulsification. Do not add more than the two parts of oil— less will suffice.

DIRECTIONS FOR USE: Make a paste of dry pigment and water, and grind this with a palette knife into the glue-oil emulsion. Paint onto glue sized paper, cardboard, panels, or canvas. Since the glue is fairly brittle, this paint is best used on rigid supports; but painted thinly, it serves well for underpainting on canvas, too. Dilute Paint No. 26 with water.

Gelatine

PURPOSE: Just as gelatine serves so well to make a fine gesso coating for rigid panels, so it performs well to make a low cost, quick drying paint.

INGREDIENTS	PARTS
Leaf gelatine	*6 leaves*
Water	*1 pint*

DIRECTIONS FOR MANUFACTURE: Follow the directions given for making Size No. 1.

DIRECTIONS FOR USE: Coat the desired support— paper, cardboard, panel, or canvas—with the warm size solution and let it dry before painting. For the paint, use dry pigments, mixing each color into a soft paste with water and keeping the gelatine solution warm enough to prevent its gelling. Use bristle brushes and mix the solution with the pigment paste on a glass palette. Very thin paint layers give the best results, for thick paint tends to crack. Harden and preserve the painting after it dries by spraying with a 4% formaldehyde solution. This formula may be used for underpainting or for alla prima.

Hide glue

PURPOSE: Hide glue, like gelatine, affords a low cost, easily formulated paint which the British call *distemper*. Diluted with water, it is good for color sketching, as well as for painting.

INGREDIENTS	PARTS
Hide glue	*1*
Water	*10*

DIRECTIONS FOR MANUFACTURE: Leave the glue in water overnight or for a full day. Let the glue absorb as much water as it can, then pour off the excess water. Warm this swollen glue in a double boiler until the material melts into solution.

DIRECTIONS FOR USE: Work the dry pigments with water into a heavy paste, and with a palette knife grind the pigment into the warm solution of glue. Keep these paints warm enough to remain in solution while painting with them, and use tepid water to dilute them. Use a bristle brush for painting, applying the paint in thin layers to glue sized paper, cardboard, panel, or canvas. Hide glue is excellent for alla prima painting and for thin underpainting. To harden and preserve, spray the dried painting with a 4% solution of formaldehyde.

Glue and oil emulsion

PURPOSE: Mixed techniques, in which different
kinds of paint are used in alternate layers, sometimes
call for an emulsion of the two kinds of paint.
This emulsion dries very quickly, but must be kept
warm while in use.

INGREDIENTS	PARTS
Hide glue solution (Paint No. 28)	2
Oil or resin solution	1

DIRECTIONS FOR MANUFACTURE: Follow the
directions given in Paint No. 28 and keep the
glue solution just warm enough to remain liquid.
A heavy bodied oil—such as sun thickened linseed
oil or stand oil—or a concentrated resin solution
is advisable. Stir the oil or resin drop by drop into
the glue solution, agitating it vigorously. Ammonium
carbonate, in solution, can be added to insure
emulsification.

DIRECTIONS FOR USE: Grind the dry pigments
with water into pastes, then use these pastes with
the emulsion. Keep the emulsion warm and liquid
while it is in use. Paint directly on sized paper,
cardboard, panel, or canvas, or use in mixed
techniques over and under oils.

Starch

PURPOSE: Cornstarch and wheat flour make good pastes and sizing material, and perform well as ingredients in quick drying, water soluble paints.

INGREDIENTS

Starch solution (Size No. 7)
(Wheat flour, cornstarch, or arrowroot)

DIRECTIONS FOR MANUFACTURE: Follow the directions given for Size No. 7.

DIRECTIONS FOR USE: Make pastes of dry pigment and water, grinding the pigments thoroughly to make the pastes smooth. Put sufficient starch solution in a paint cup, and make the paint by dipping the brush alternately into the starch solution and the pigment paste. Use bristle brushes, diluting the paint with enough water to apply the paint thinly where you want to avoid cracking. To harden and preserve this paint, spray the dried painting with a 4% formaldehyde solution. Starch paint works well where permanence is not necessary.

Starch and oil emulsion

PURPOSE: Glue and starch paints cover very well for temporary purposes; a little oil or resin added to these paints renders them more permanent, yet does not slow their drying speed.

INGREDIENTS	PARTS
Starch solution (Size No. 7)	*4*
Oil or resin solution	*1*

DIRECTIONS FOR MANUFACTURE: Use the ingredients at room temperature. Add the oil to the starch solution, a little at a time, until all the oil is used up. Stir as you add. Or place the starch solution in a small jar, add the oil, and shake it well. A small amount of ammonium carbonate—either pulverized or in solution—can be added to guarantee complete emulsification.

DIRECTIONS FOR USE: Use the emulsion with dry pigments, making a paste of the pigments with water; then combine the emulsion and pigment paste with a palette knife on the palette. Apply the paint with bristle brushes to glue sized paper, cardboard, panel, or canvas. This material works best when it is brushed on in thin coats, using proportionately less pigment than emulsion. When dry, protect the painting either with varnish or fixative.

Pastels

PURPOSE: When you keep a good stock of dry pigments on hand, you'll find making your own color range of pastels an easy matter.

INGREDIENTS

Gelatine solution (Size No. 1) or
Gum tragacanth solution (Paint No. 38)
Dry pigments and zinc white

DIRECTIONS FOR MANUFACTURE: Make either of the two solutions listed above (Size No. 1 or Paint No. 38). The tragacanth solution is just right for use, but the gelatine solution should be diluted with an equal amount of water. To equal parts of dry pigment and zinc white, add just enough water to make a stiff paste. Then add enough gum or gelatine solution to allow grinding with the palette knife until the paste is completely smooth. Deposit the soft color paste on a blotter or on newsprint and let it absorb most of the moisture; then shape the drying paste into sticks— or whatever form you wish—and let them dry slowly near heat or at room temperature.

DIRECTIONS FOR USE: Apply pastels directly to pastel paper or cardboard (see Ground No. 15) and use in the traditional manner; or combine with other media such as gouache, glue paints, or synthetic resins.

Casein

PURPOSE: Casein paints rapidly dry to a matte surface. Freshly made casein produces a very tough, water-resistant paint.

INGREDIENTS

Casein solution (Size No. 4)
Dry pigments

DIRECTIONS FOR MANUFACTURE: Follow the directions given for Size No. 4. With the palette knife combine the dry pigments and size, adding water to make a paste. It is necessary to grind the dry pigments well to insure a smooth paint.

DIRECTIONS FOR USE: Prepare the support—paper, cardboard, panel, or canvas—by sizing it first with Size No. 4, and than applying a casein ground (Grounds No. 11 through 14). Paint with bristle brushes, taking care to keep the brushes in water when they are not being used, and carefully washing them out with soap after use—for casein is hard on brushes. Casein may be painted over with oil or resin paints, or can be made to resemble oil by giving the picture a heavy varnish after it has dried.

Casein and lime

PURPOSE: Perhaps the toughest—and certainly the freshest—casein is that formulated in the ancient manner with lime. This casein serves to make a ground or a size, as well.

INGREDIENTS	PARTS
Dry curd cheese	5
Lime putty (Size No. 11)	1

DIRECTIONS FOR MANUFACTURE: From a delicatessen, you can buy dry curd cheese, which is cottage cheese without cream or flavoring. Make the lime putty according to the directions given in Size No. 11; add the thick putty to the cheese, and stir them together. Leave them for a few hours—the cheese lumps will dissolve completely. Select lime-proof dry pigments and work them up with water into a paste. These may then be combined with casein solution, or kept separate for future use.

DIRECTIONS FOR USE: Size and then ground mounted cardboard or a panel; use Size No. 4, or the above casein solution, thinned with water. Rigid supports are advisable for this paint, which becomes very hard. You may also use casein-lime as a thin underpaint for oils or paint directly in this material to keep a dull finish.

Casein and oil emulsion

PURPOSE: Thick, quick setting impasto for mixed technique calls for a union of virtues. Casein paint with a little oil does the job.

INGREDIENTS	PARTS
Casein solution (Size No. 4)	*2*
Stand oil, heavy body	*1*
Dry pigments	

DIRECTIONS FOR MANUFACTURE: With the casein solution and dry pigments work up your colors on the palette. Use a palette knife to grind each pigment to a fairly stiff consistency with the casein; this permits finer grinding of pigment and produces the thick paint desired. Drop by drop, add the stand oil and work it into each mound of casein paint. If necessary, add a little ammonium carbonate, pulverized, to insure that the oil and casein will combine. This emulsion can be diluted with water.

DIRECTIONS FOR USE: Apply this emulsion full strength to a casein sized panel if you use thick paint; dilute and use thinly on canvas; or paint wet-in-wet into fresh oil paint. The formula can be varied to include a greater percentage of oil, which will give greater flexibility. This quick drying paint will set up in 10 minutes and must be used while fresh.

Gum-water solution

PURPOSE: Water soluble gums constitute a major
ingredient in the manufacture of paint, for they
are easily formulated, non-toxic, and quick drying.
Gum arabic is one of the most commonly employed.

INGREDIENTS	PARTS
Gum arabic	1
Water	2

DIRECTIONS FOR MANUFACTURE: In a double boiler,
heat the water and stir in the gum arabic.
Powdered gum takes less time to dissolve than
lumps, but complete dissolution still requires about
two days. After the solution cools, cover and leave
it until the solution is clear and complete. Strain
the gum-water through cheesecloth into a clean
jar. Keep refrigerated when not using, for this
material spoils easily. Never heat this solution over
direct flame, for it will scorch.

DIRECTIONS FOR USE: Mix your dry pigments with
the gum-water into a thick paste, and use on
paper or cardboard. For on opaque gouache
technique, use a large proportion of pigment to
gum solution. For a transparent watercolor
technique, dilute the solution with water. When
the painting has dried, it may be varnished or
sprayed with fixative for protection.

Gum, stand oil, damar resin emulsion

PURPOSE: Join the quick drying qualities of gum arabic solution with the permanence and toughness of stand oil and damar resin, and the combination retains the virtues of all.

INGREDIENTS	PARTS
Gum arabic solution (Paint No. 36)	5
Stand oil, heavy bodied	1
Damar varnish (Varnish No. 1)	1

DIRECTIONS FOR MANUFACTURE: Combine all the ingredients at room temperature in a clean bottle; cap and shake vigorously to emulsify.

DIRECTIONS FOR USE: Use any support—paper, cardboard, panel, or canvas—and size it with glue or gelatine. Make a paste of dry pigment and water, combine this paste with the emulsion, and apply to the support with bristle brushes, either alla prima or for underpainting. Thin coats of paint dry within two hours, and can then be painted over. Dilute this paint with water.

Gum-water and alcohol solution

PURPOSE: Gum tragacanth, unlike gum arabic, does not really dissolve with water into a true solution. Instead, it absorbs water, forming a suspension.

INGREDIENTS	PARTS
Gum tragacanth	1
Distilled water	30
Alcohol (or wine)	enough to moisten the gum

DIRECTIONS FOR MANUFACTURE: Gum tragacanth is generally available in powdered form. Put the gum into a clean bottle and stir in enough alcohol to make a very soft paste. Add the water last, and shake all together. Tragacanth can't be hurried; it will require about two days to absorb all the water and to swell into a gelatinous suspension.

DIRECTIONS FOR USE: Make a paste of dry pigments and water, and grind with the gum solution to make the paint. Apply with bristle brushes either to sized or unsized paper or fabric. If you paint thickly, apply the paint to rigid supports; when the paint has dried, protect it with a resin varnish or a fixative.

Acrylic resin and oil

PURPOSE: Many painters prefer the characteristics of traditional oil paint, but envy the rapid drying qualities of synthetic resin water emulsion paints. This formula takes advantage of both media.

INGREDIENTS	PARTS
Acrylic solution (Varnish No. 28)	2
Raw or sun thickened linseed oil	1

DIRECTIONS FOR MANUFACTURE: Combine the ingredients in a clean bottle, and shake or stir until they form a consistent solution.

DIRECTIONS FOR USE: This solution can be used either with dry pigments (which have been ground into a paste with a little oil or turpentine) or with tube oil paints. The higher the percentage of oil, the more slowly the paint will dry. The solution alone dries completely in about four hours. Size any kind of support—paper, cardboard, panel or canvas—with this thinned solution before you paint with bristle brushes. This paint is tough, permanent, and flexible. Use turpentine or toluene for cleaning your brushes. If you want a high gloss, brush the painting lightly with alcohol when the painting is dry; to reduce the gloss, wax the painting.

Lime water (fresco secco)

PURPOSE: True fresco (or *buon fresco*) possesses unusual qualities, but demands extensive and careful handling. Where immediacy is more important, painters turn to the less magical but simpler technique known as *fresco secco*.

INGREDIENTS	PARTS
Lime	*1*
Water	*5*

DIRECTIONS FOR MANUFACTURE: Caustic lime (or *fat* lime) is extremely dangerous to handle; *wear gloves and keep your skin covered.* Sprinkle the lime into the water, using an enameled or steel container, for the solution will become very hot. Stir the solution until it begins to thicken. Use the water which remains standing above the solid to make the paint.

DIRECTIONS FOR USE: First size the plaster wall with the lime water, brushing and splashing it on with a wooden bristle brush, and let it dry. Grind lime-proof pigments into a soft paste with the lime water, and keep them in small jars for convenient use. Select soft bristle brushes, for lime is hard on delicate brushes; after use, be sure to wash out the brushes with soap and water. Pure lime putty serves well for whites, and cross-hatching strokes show up well in this technique.

Silica resin and alcohol

PURPOSE: A formula which has been used by artists for only three decades permits decorating exterior masonry with a paint which, to date, appears to be very long lasting.

INGREDIENTS	PARTS
Tetraethyl orthosilicate	*50*
Denatured alcohol	*30*
Distilled water	*1*
Distilled water	*9*

DIRECTIONS FOR MANUFACTURE: Combine the first three ingredients and let them stand for at least 24 hours. After the second addition of water is made, the mix is ready for use. The first mixture can be stored safely if tightly stoppered.

DIRECTIONS FOR USE: Use only lime-proof pigments, and apply the paint in a fresco or tempera technique—thinly, directly, and with a minimum of working over; heavy layers will not be permanent. Keep the brushes moist in the paint medium and use no diluent to thin it further; use alcohol to clean the brushes after use, while the medium is still wet on them. Paint No. 41 can be used on stucco, concrete, or any porous brick.

Silica resin, alcohol, acid

PURPOSE: Ralph Mayer, whose experiments with this medium are definitive, believes this formula permits a slight dilution of the paint with volatile solvent, i.e., alcohol.

INGREDIENTS	PARTS
Ethyl silicate No. 40	*80*
Denatured alcohol	*18*
3% hydrochloric acid	*2*
Distilled water	*5*

DIRECTIONS FOR MANUFACTURE: The dilute acid solution can be made by adding one part of hydrochloric acid, C.P., to 120 parts of distilled water. Combine the alcohol and acid solution, then mix in the ethyl silicate No. 40 (Union Carbide, under *Sources*). After 24 hours add the water, then grind lime-proof pigments with the medium.

DIRECTIONS FOR USE: This formula is nearly identical to Paint No. 41 and requires careful preparation and the willingness to accept the same limitations which apply to the other paint. Thin cross-hatching of color, which remains as porous as the surface on which it is applied, promises the greatest permanence and brilliance of effect.

Mediums

Oil, damar, mastic resin

PURPOSE: Resins, with their clarity and hardness, combine well with the tough qualities of oils and add brilliance to the handling of glaze coats.

INGREDIENTS	PARTS
Walnut, poppy, or linseed oil	*4*
Damar lumps	*2*
Mastic tears	*1*
Turpentine or benzene	*4*

DIRECTIONS FOR MANUFACTURE: Turpentine only partially dissolves mastic resin at room temperature; benzene, over a period of two to three days, will completely dissolve it. If you use turpentine, heat all the ingredients together over an electric unit until they dissolve. Decant the solution into a clean bottle. If you perfer to use benzene, bottle all the ingredients and leave them at room temperature until the resins dissolve.

DIRECTIONS FOR USE: This solution can be mixed with tube oil colors as a medium; thinned for use as a glaze; or applied thinly over finished and thoroughly dry oil paintings as a varnish. Medium No. 1 dries in 1½ or 2 days.

Damar resin and oil

PURPOSE: After developing an oil painting in turpentine-diluted layers followed by a layer of straight oil paint, the subsequent addition of a resinous medium fulfills the "fat over lean" dictum for sound painting.

INGREDIENTS	PARTS
Damar varnish (Varnish No. 1)	1
Raw linseed oil	1
Turpentine	1

DIRECTIONS FOR MANUFACTURE: Combine all the ingredients at room temperature. Sun thickened linseed oil or stand oil, heavy bodied, may be substituted for raw linseed oil.

DIRECTIONS FOR USE: Mix the medium with tube oil paints directly on the palette. This medium may also be used for glazing. Its oil content is too high for use as a final varnish. Dry pigments, ground first on the palette with a little medium, dry a little more rapidly than do tube oil paints; the substitution of heavy bodied oils for raw linseed further accelerates the drying rate. As given, this medium dries in two days.

Damar or mastic resin and oil

PURPOSE: Damar and mastic resins are the most serviceable of the natural soft resins. With their fast drying rates, they maintain a clear and tough film with a bodied oil.

INGREDIENTS	PARTS
Damar varnish (Varnish No. 1)	
or	
Mastic varnish (Varnish No. 2)	2
Sun thickened linseed oil	1

DIRECTIONS FOR MANUFACTURE: Combine and mix the ingredients together at room temperature. A heavy bodied stand oil may be substituted for sun thickened linseed.

DIRECTIONS FOR USE: Mix this medium on the palette with tube oil paints for painting, or with dry pigments for painting and for glazing. Dry pigments should be ground with a small amount of medium to a stiff paste in order to make them smooth enough for glazing. Heavy bodied oils reduce the drying rate of this medium to $1\frac{1}{2}$ days. Not recommended for use as a final varnish; the percentage of oil is too high.

Damar resin, oil, balsam

PURPOSE: Balsams, it has been proposed, provide a certain amount of protection where incompatible pigments are used in the same painting. Venice turpentine is one of the most widely used balsams.

INGREDIENTS	PARTS
Damar varnish (Varnish No. 1)	4
Sun thickened linseed oil	2
Venice turpentine	1

DIRECTIONS FOR MANUFACTURE: Combine all the ingredients at room temperature and shake them into a homogeneous solution. This procedure produces a fairly thick medium.

DIRECTIONS FOR USE: Combine this medium on the palette with tube oil paints. Use it for painting over layers of tube oil paint. Rich in resin and balsam, Medium No. 4 should not be used in undercoats. Ground with dry pigments, it makes an excellent glazing medium and can be thinned considerably with turpentine. Because Venice turpentine is relatively slow in drying, Medium No. 4 dries in three days.

Stand oil and damar resin

PURPOSE: Stand oil (thickened and polymerized by letting it age or "stand") dries more rapidly than raw linseed oil and shares this virtue with fast drying damar resin.

INGREDIENTS	PARTS
Stand oil, heavy	1
Damar varnish (Varnish No. 1)	1
Turpentine	5

DIRECTIONS FOR MANUFACTURE: Combine all the ingredients at room temperature and shake them until they form a homogeneous solution.

DIRECTIONS FOR USE: Mix the medium on the palette with tube oil paints for direct painting or for glazing over oil paint. The viscosity, or thickness, of this medium can be altered by using more or less turpentine. The drying time of this medium—two days—can be maintained for glazing by using dry pigments instead of tube oil paint.

Damar resin, stand oil, toluene

PURPOSE: To touch up a painting after it is practically done—and when it has had little time to dry—calls for an almost "instant paint"; this formula is nearly that.

INGREDIENTS	PARTS
Damar varnish (Varnish No. 1)	*10*
Stand oil, heavy	*2*
Toluene	*1*
Alcohol	*1*

DIRECTIONS FOR MANUFACTURE: Combine all the ingredients at room temperature in a bottle, and agitate until they combine thoroughly and become clear (cloudy-clear).

DIRECTIONS FOR USE: This medium is excellent for final paint layers over oil, and will serve well as a final varnish. The high percentage of resin performs well as a varnish, while the stand oil unites with the oil paint. Combine this medium on the palette with tube oil paint or with dry pigment and apply as a glaze or final paint layer. A thin coat of this medium dries within one hour.

Damar or mastic resin and wax

PURPOSE: Known for many centuries for its permanance and impermeability, beeswax combines well with resins and oils, and reduces some of the high gloss while it thickens the paint.

INGREDIENTS	PARTS
Damar varnish (Varnish No. 1)	
or	
Mastic varnish (Varnish No. 2)	1
Wax varnish (Varnish No. 21)	1

DIRECTIONS FOR MANUFACTURE: Combine and warm the ingredients over an electric unit, stirring them until they combine completely. Cool the mixture and pour into a bottle.

DIRECTIONS FOR USE: This combination of resin and wax is excellent for final paint layers and requires no final varnish when the medium has been applied with little paint. This medium serves to thicken tube oil paints. For use as a final picture varnish Medium No. 7 should be thinned with turpentine; if dry pigments are ground with the medium, apply only as a final paint layer. The low gloss finish dries in one half hour.

Damar resin and beeswax

PURPOSE: An increase in the amount of wax brings about the buttery quality desired by many painters, and reduces the gloss of the paint surface when it dries.

INGREDIENTS	PARTS
Damar varnish (Varnish No. 1)	4
Beeswax	2
Turpentine	1

DIRECTIONS FOR MANUFACTURE: Combine the ingredients in a double boiler and heat over an electric hotplate until the wax has dissolved. Remove the mixture from the heat and stir while it cools.

DIRECTIONS FOR USE: This formula produces a soft paste; if you prefer a solution, stir in twice the amount of turpentine while the solution is still hot. By grinding the paste with dry pigments, you can make an encaustic paint for melting on the panel. Combined on the palette with tube oil paints, the medium thickens the paint and produces a soft finish. For use as a final varnish, apply Medium No. 8 thinly with a clean, lint free cloth and leave alone for a dull finish. When thoroughly dry, the finish can be polished to a soft luster. A thin film of this medium dries in 30 minutes.

Mastic resin and balsam

PURPOSE: The clarity and non-yellowing characteristics of balsam can be joined with the fast drying qualities of resins to produce an excellent medium for use over oil paint.

INGREDIENTS	PARTS
Mastic varnish (Varnish No. 2)	*4*
Venice turpentine	*1*

DIRECTIONS FOR MANUFACTURE: Venice turpentine is one of the most viscous—and *sticky*—materials to deal with, so handle it with dexterity. Combine Venice turpentine with the mastic varnish and either warm the ingredients together in a double boiler, or put them in a clear glass bottle and place in warm sunlight to insure complete mixing.

DIRECTIONS FOR USE: Since this medium contains no oil, it is best to mix the medium on the palette with tube oil paint. Apply this mixture to the topmost layers of paint in an oil painting. If you use dry pigments, grind them well into the medium and apply as final glaze layers. The medium can be thinned with turpentine and brushed on as a final varnish. A thin coat of the medium dries in 30 minutes.

Mastic resin, oil, wax

PURPOSE: Sun thickened linseed oil—made by exposing raw linseed oil in shallow pans to direct sunlight—is heavier and dries slightly faster than stand oil.

INGREDIENTS	PARTS
Mastic varnish (Varnish No. 2)	*10*
Sun thickened linseed oil, heavy	*20*
Wax varnish (Varnish No. 21)	*1*

DIRECTIONS FOR MANUFACTURE: Combine and heat all the ingredients in a double boiler, stirring them together until they are completely blended.

DIRECTIONS FOR USE: This medium has a heavy concentration of oil which slows its drying rate somewhat. Because of this high percentage of oil, the medium is best used with dry pigments and applied as final paint layers. If you combine Medium No. 10 with tube oil paint, be very sparing and be sure to apply only over layers of rich oil paint. A thin coat of medium dries in three days.

Balsam and oil

PURPOSE: For a high gloss and a strong protective
final coat, a combination of balsams with linseed
oil is excellent and, paradoxically, dries more rapidly
than either ingredient would dry alone.

INGREDIENTS	PARTS
Venice turpentine	*4*
Raw linseed oil	*1*

DIRECTIONS FOR MANUFACTURE: Combine the
ingredients at room temperature, or warm to
speed up their complete union. These combine to
make a very heavy consistency, for the Venice
turpentine is exceedingly thick.

DIRECTIONS FOR USE: Combine on the palette
with tube oil colors and apply to oil paintings for
final paint layers. This medium should also be
used wherever colors of doubtful compatibility
are to be glazed one over the other, for Venice
turpentine seems to prevent their destroying one
another. Grind this medium with dry pigments and
use as thin glazes, rubbing them onto the painting
with a cloth or with your fingers. Diluted with
turpentine, this medium runs easily and dries
in 1½ days.

Canada balsam and sun thickened oil

PURPOSE: Fragrant, viscous like Venice turpentine, water clear—and *very* expensive—Canada balsam is worth every penny, for it is unequaled in clarity and drying time.

INGREDIENTS	PARTS
Canada balsam	4
Sun thickened linseed oil	1
Turpentine	2

DIRECTIONS FOR MANUFACTURE: Combine and warm the ingredients either in hot sunshine or over a double boiler, and stir them until they mix completely.

DIRECTIONS FOR USE: Extolled by Laurie for its molecular properties and said to resemble closely the legendary, but unavailable, *olio d'Abezzo* or Strasbourg turpentine, Canada balsam with oil may be mixed on the palette with tube oil paint for glazing or for painting the last thin coats over oil. For use as a final picture varnish, dilute Medium No. 12 further with turpentine to permit a very thin application. A thin coat of this medium dries within 30 minutes. Oregon balsam, although extremely dark, performs quite like Canada balsam, yet costs much less.

Venice turpentine and sun thickened oil

PURPOSE: Achieving a soft and indiscernible fusion of colors requires a fairly slow drying, thixotropic medium, as well as skill; linseed oil with Venice turpentine fulfills the former requirements.

INGREDIENTS	PARTS
Sun thickened linseed oil, heavy	1
Venice turpentine	1
Turpentine	1

DIRECTIONS FOR MANUFACTURE: Combine and stir all the ingredients in a double boiler over heat until a homogeneous mixture is achieved. Stand oil, heavy bodied, may be substituted for sun thickened linseed, and Canada balsam used instead of Venice turpentine.

DIRECTIONS FOR USE: Heavy in oil, this medium should be used sparingly with tube oil paints, except in final paint layers. For glazes, grind this medium with dry pigments and apply very thinly with a cloth or with your fingers. A medium-thin coat of this formula will dry in two days; the substitution of Canada balsam for Venice turpentine reduces considerably the drying time.

Balsam and beeswax

PURPOSE: In the encaustic technique colors are
melted one over the other to produce deep,
jewel-like effects. This medium can also be used
in direct painting.

INGREDIENTS	PARTS
Venice turpentine	2
Beeswax	1
Turpentine	3

DIRECTIONS FOR MANUFACTURE: Combine the
Venice turpentine and beeswax, and stir them
together over heat until the wax has melted and
mixed thoroughly with the balsam. Add the
turpentine slowly (not over an open flame) until
all are blended.

DIRECTIONS FOR USE: For use in encaustic, grind
this medium with dry pigments and apply to a
rigid panel, melting the paint with a heat lamp
or with an open flame. To use as a medium
in direct painting, grind on the palette with tube
oil paints, diluting as necessary with turpentine;
the wax will thicken and soften the oil paint. As
a painting medium, this formula should be used
for final paint layers and left unvarnished. This
medium dries in 15 minutes.

Balsam, mastic, copal resin, oil

PURPOSE: The brilliance of Canada balsam, united with the rapid drying rate of a soft resin and the hardness of the copal fossil, produce a most desirable medium.

INGREDIENTS	PARTS
Canada balsam	*2*
Mastic varnish (Varnish No. 2)	*1*
Oil-copal varnish (Varnish No. 7)	*1*

DIRECTIONS FOR MANUFACTURE: Stir all the ingredients together in a double boiler over heat until the extremely heavy, viscous balsam has combined smoothly with the other ingredients. This procedure will produce a fairly heavy medium which can be diluted with turpentine.

DIRECTIONS FOR USE: Since only a small quantity of oil is present, this medium can be thinned with turpentine and used to advantage as a final picture varnish. A. P. Laurie suggests that Medium No. 15 very closely resembles the characteristics of the medium used by Jan Van Eyck. Mix Medium No. 15 with either tube oil paint or dry pigment to paint the last layers or to apply glazes. This formula dries in 1½ hours.

Copal resin and stand oil

PURPOSE: Copal resin has the quality of making oil paint stay put, preventing the tendency to sag or run. For centuries the hardness of copal made it the favorite material for use in exterior varnishes to resist weathering.

INGREDIENTS	PARTS
Oil-copal varnish (Varnish No. 7)	2
Stand oil, heavy	1
Turpentine	2

DIRECTIONS FOR MANUFACTURE: Stir all the ingredients together (or shake them in a bottle) until they have combined. This formula produces an average consistency which can be varied by the amount of turpentine you choose to add.

DIRECTIONS FOR USE: Because of its high percentage of hard copal resin, this medium works best used with tube oil colors, and for glazing or painting final layers of oil on the picture. Moderate in its drying rate (1½ days), this formula can be combined with wax pastes or solutions to accelerate drying.

Oil and copal resin

PURPOSE: A thin, oily medium permits the dilution of paint to achieve the most ethereal effects without the loss of binding power.

INGREDIENTS	PARTS
Oil-copal varnish (Varnish No. 7)	*1*
Raw linseed oil or poppy oil	*2*

DIRECTIONS FOR MANUFACTURE: Combine the ingredients at room temperature, shaking them to insure complete mixing.

DIRECTIONS FOR USE: This medium can be used with tube oil paints or with dry pigments in direct painting or for glaze layers. Because of the high percentage of oil, however, Medium No. 17 is not suitable as a final picture varnish. It is best applied in *final* paint layers or glazes, over normal oil paint, for it is extremely fat. The copal adds hardness to the toughness of linseed, but the medium dries slowly, requiring three days. Its drying rate can be further retarded by using the alternative poppy oil.

White lead and copal

PURPOSE: Part ground, part medium, this formula is designed specifically to be applied over Lead-Copal Ground No. 1. Used by the Pre-Raphaelite painters, it apparently provided a permanent and brilliant medium.

INGREDIENTS	PARTS
White lead in oil	*3*
Oil-copal varnish (Varnish No. 7)	*1*

DIRECTIONS FOR MANUFACTURE: First extract all excess oil from the white lead by leaving it on absorbent paper (brown wrapping paper or newsprint) for two or three days. Four or five layers of heavy brown paper will do the job well. After this time, grind the white lead with the copal and oil varnish on the palette to a smooth consistency.

DIRECTIONS FOR USE: This technique requires precise planning, so have a design already drawn, in charcoal or paint, on the ground. Spread the medium over the drawing, thinly enough so that the underdrawing is barely visible. Use a medium or glaze containing oil-copal varnish, and paint directly into the wet medium with sable brushes and tube oil paints. Take care not to pick up the white; do not retouch or work over. This medium dries in 30 minutes to full brilliance of color.

Wax paste

PURPOSE: When you wish to thicken (or make buttery) the normal oil paint consistency, nothing is better than beeswax for the purpose.

INGREDIENTS	PARTS
Beeswax	*1*
Turpentine	*3*

DIRECTIONS FOR MANUFACTURE: Over an electric hotplate, warm the ingredients together until the beeswax has melted into the solution. Remove from the heat and stir occasionally until the solution cools to a soft paste.

DIRECTIONS FOR USE: This formula provides a staple for all-around use—for making encaustic formulas, for modifying oil paints, for making emulsions, and for final varnishing of paintings in all media. In direct painting, combine the medium on the palette with tube oil colors, applying thick or thin coats over oil, tempera, or glue paints. Because of the presence of wax, however, do not apply any varnish except a wax varnish after the painting has dried. Very thin glaze layers, or scumbles, can be applied with this medium. Medium No. 19 dries in 30 minutes.

Wax, damar resin, oil

PURPOSE: For a thick, buttery, but light consistency in an oil paint, wax combines well with fast drying soft resin and heavy oil.

INGREDIENTS	PARTS
Beeswax	*4*
Damar varnish (Varnish No. 1)	*1*
Sun thickened linseed oil	*1*
Turpentine	*12*

DIRECTIONS FOR MANUFACTURE: Over a covered electric hotplate, heat all the ingredients until the wax melts into solution and stir. Remove from the heat and stir until the solution cools to a soft paste. For encaustic techniques, the turpentine can be reduced by two thirds or left out completely to make a firm solid.

DIRECTIONS FOR USE: Combine the soft paste on the palette with tube oil paints to apply as final paint layers or as glazes. Varnish over these only with a wax varnish. For encaustic, combine with either tube oil paint or with dry pigment and apply on rigid panels. Medium No. 20 sets immediately and dries in 30 minutes.

Wax, damar resin, oil for sketching

PURPOSE: Spontaneous, vivid sketches rendered in gum, glue, or casein may be further developed by painting over with a thixotropic medium. This formula is also excellent for making encaustics.

INGREDIENTS	PARTS
Beeswax	8
Damar varnish (Varnish No. 1)	1
Sun thickened linseed oil	1
Turpentine	10

DIRECTIONS FOR MANUFACTURE: Heat all the ingredients together over a covered electric hotplate until the wax has melted into the solution; then remove from the heat and stir until the solution cools to a paste.

DIRECTIONS FOR USE: For use in encaustic, grind the paste with either tube oil paints or with dry pigments; apply to rigid panels, and heat with a lamp or with a torch. For oil painting, combine with tube oil paints; dilute as necessary with turpentine; and apply as final paint layers or glazes. This medium may be used as a final varnish to produce a soft, low luster. This formula sets immediately and dries in 30 minutes.

Spirit-fresco

PURPOSE: In the nineteenth century, Gambier Parry developed this formula for painting upon plaster walls, stone, or other dry, porous materials.

INGREDIENTS	PARTS
Beeswax	4
Elemi resin	2
Oil-copal varnish (Varnish No. 7)	16
Turpentine	2
Oil of spike lavender	8

DIRECTIONS FOR MANUFACTURE: Combine all the ingredients and heat them together over an enclosed electric hotplate until the wax and resins have dissolved completely and gone into solution. Remove from the heat, stir and pour slowly into jars or metal containers for storage.

DIRECTIONS FOR USE: This formula produces a consistency like that of paste shoe polish and may be applied with a stiff brush in the same manner to size the plaster or stone support. Allow each coat to dry a day or so. You may grind white pigment and whiting into the medium and apply the mixture as a ground. To paint over the size or the ground, grind the medium with dry pigments, using turpentine as a thinner. Allow Medium No. 22 to dry two or three weeks and do not varnish.

Spirit-fresco (simplified)

PURPOSE: To simplify Gambier Parry's formula and to delete what he considered "doubtful" ingredients, A. H. Church altered the preceding formula and reduced the number of ingredients to three.

INGREDIENTS	PARTS
Oil-copal varnish (Varnish No. 7)	*16*
Paraffin (or Ceresin)	*4*
Turpentine	*12*

DIRECTIONS FOR MANUFACTURE: Combine all the ingredients and heat them together over an enclosed electric hotplate until the wax has dissolved into the solution. Remove from the heat and stir to insure thorough mixing. While the solution is still hot, pour it into jars or metal containers for storage. After cooling, the mixture forms a firm paste.

DIRECTIONS FOR USE: This medium should be used in exactly the same fashion as Medium No. 22. Medium No. 23 may be applied in a technique similar to traditional "buon fresco"—cross-hatching with dark colors to express form—but it should also combine easily with tube oil colors and may be diluted for a loose, fresh handling.

Wax and elemi resin

PURPOSE: Elemi resin, used to impart tackiness
to wax formulas, is often sold in a soft state,
heavily mixed with bugs, insects, and odd pieces
of tree bark. Its precise virtues and weaknesses
are vague, but it dries rapidly and is definitely
sticky.

INGREDIENTS	PARTS
Elemi resin	*1*
Beeswax	*1*
Turpentine	*2*

DIRECTIONS FOR MANUFACTURE: Combine all the
ingredients and heat them over an enclosed electric
hotplate until the wax and resin have melted
into a clear solution. Remove from the heat and
stir to insure blending; then pour, while still
hot, through cheesecloth into jars or metal
containers. This mixture cools to a soft paste. Oil
of spike lavender can be substituted for turpentine
or combined with it.

DIRECTIONS FOR USE: Apply as encaustic by
grinding this medium with dry pigments and
painting on rigid panels. In oil painting, the
medium can be added to thicken the paint and to
accelerate the drying time. The medium dries
in three hours.

Egg and damar resin emulsion

PURPOSE: The omnipotent egg, emulsified with fast drying damar resin, provides a vehicle for making paint, for making isolating varnish, and for carrying out minute detail in wet oil paint.

INGREDIENTS	PARTS
Egg yolk	*1*
Damar varnish (Varnish No. 1)	*1*

DIRECTIONS FOR MANUFACTURE: Discard the egg white and dry the yolk membrane by passing it gently from one palm to the other. Puncture and drain the pure yolk into a small jar; and stir in the varnish, adding only a few drops at a time. When all the varnish has been incorporated, you may add water in the same fashion, if you wish.

DIRECTIONS FOR USE: This medium can be added to pigment-water pastes for use in egg tempera painting or used to serve as a paint layer between an underpainting of glue or casein and an overpainting with oils. To add fine detail, you can apply it wet-in-wet to oil paint. Very much diluted with water, Medium No. 25 serves as an isolating varnish. This medium dries in 15 minutes or less.

Egg and wax emulsion

PURPOSE: When you want a particularly heavy, or thick impasto from tube oil paint, an emulsion is often the easiest way to bring it about. Egg yolk is a natural oil-in-water emulsion.

INGREDIENTS	PARTS
Egg yolk	*1*
Beeswax varnish (Varnish No. 21)	*1*

DIRECTIONS FOR MANUFACTURE: After obtaining pure egg yolk—as directed in Medium No. 25—stir it, drop by drop, into the beeswax varnish. Stir vigorously to insure complete emulsification. This emulsion can be diluted with turpentine.

DIRECTIONS FOR USE: Mix this medium with tube oil colors on the palette, or grind with dry pigments made into a paste with turpentine. Very good for executing fine detail, painting wet-in-wet into fresh oil paint, this medium can also be used for intermediate glazes over egg, glue, or casein tempera. It dries almost instantly. Since eggs spoil easily, make this emulsion fresh as needed; a few drops of oil of cloves or vinegar help to retard spoilage, however.

Acrylic and toluene

PURPOSE: For the Impatient Expressionist, modern science has concocted a splendid synthetic resin which is water clear, dries in 30 minutes, yet is compatible with oil paint.

INGREDIENTS	PARTS
Acrylic resin (white powder)	2
Toluene	1

DIRECTIONS FOR MANUFACTURE: If you use white resin powder, fill a bottle to the top with it, then add the toluene and cap securely. Place in the sun or in a warm spot to accelerate dissolution and to produce a water clear solution. Or use acrylic toluene solution, which can be purchased ready for use. See the sources at the end of the book to obtain these ingredients.

DIRECTIONS FOR USE: Combine this medium with tube oil paints on the palette, or with dry pigments ground with turpentine or toluene, and apply to canvases or panels. This medium dries very rapidly, so use it with dispatch, and be careful to add solvent—either toluene or turpentine—to prevent hardening on the palette. It dries in 30 minutes.

Glazes

Damar resin

PURPOSE: For the final laying on of transparent color over a painting which is complete in its basic structure, a soft resin dries rapidly and bonds well with the final picture varnish.

INGREDIENTS

Damar varnish (Varnish No. 1)

DIRECTIONS FOR MANUFACTURE: Follow the directions given for Varnish No. 1. This simple formula, made fresh in the studio, is slightly cloudy and pale yellow—unlike the commercial preparations, which are nearly water-clear. The homemade product, however, is far more useful, for it is heavier and can be utilized completely to suit the painter's tastes and preferences.

DIRECTIONS FOR USE: Keep this glaze in a paint cup on the palette table, and combine it with tube oil paints by dipping out the glaze and mixing with the brush directly with the paints. The oil in the paint combines with the damar to give toughness, while the resin accelerates the drying time tremendously. This glaze, by itself, dries within one hour. Apply the glazes with a brush, a rag, or with your fingers.

Stand oil and damar resin

PURPOSE: It is often desirable to make glazes from dry pigments; for this purpose, an oil is needed to contribute toughness to the thin, final coat.

INGREDIENTS	PARTS
Stand oil, heavy	*1*
Damar varnish (Varnish No. 1)	*1*
Turpentine	*5*

DIRECTIONS FOR MANUFACTURE: Combine the ingredients at room temperature, shaking them together in a clean bottle to insure complete blending. Sun thickened linseed oil—another heavy bodied oil—may be substituted for stand oil; the amount of turpentine depends solely upon individual preferences for a thinner or thicker glaze medium.

DIRECTIONS FOR USE: Mix the glaze on the palette with either dry pigments or tube oil paints. Glazes you intend to brush on should have a thin consistency; those you mean to apply with a rag or with your fingers will handle more easily if they are thick and syrupy. Rub on the glaze as thinly as you wish. This formula dries in two days.

Damar resin, stand oil, toluene

PURPOSE: Because heavy bodied oils tend to yellow less than raw oils, they serve well in glaze formulas, where the binding medium predominates.

INGREDIENTS	PARTS
Damar varnish (Varnish No. 1)	*10*
Stand oil, heavy	*2*
Toluene	*1*
Alcohol	*1*

DIRECTIONS FOR MANUFACTURE: Combine the varnish and oil at room temperature to make a fairly heavy, pale yellow glaze. If a thin consistency is desired, add the solvents and blend by shaking them together in a clean bottle. When the alcohol is added, the mixture clouds briefly, but clarifies almost immediately. Turpentine may be substituted for the two solvents listed. This resin-oil glaze dries in one hour.

DIRECTIONS: If you use this glaze with dry pigments, or if you apply it with a rag or your fingers, it is better not to add any solvent. Thinned with solvent and brushed on, the glaze medium serves as a retouch varnish which may be painted into with fresh oil and medium.

Damar or mastic resin and oil

PURPOSE: When glazes are to be manipulated, or
rubbed about and softened at the edges, a higher
percentage of oil permits slower drying, more time
for considering, altering—or removing and replacing
with another color.

INGREDIENTS	PARTS
Damar varnish (Varnish No. 1)	
or	
Mastic varnish (Varnish No. 2)	2
Sun thickened linseed oil	1

DIRECTIONS FOR MANUFACTURE: Combine the two
ingredients at room temperature. Although some
authorities judge mastic resin less desirable than
damar for use in paint mixtures, no decisive
conclusions are available. Stand oil, heavy, may be
substituted for sun thickened oil. Thin or dilute
the mixture with turpentine.

DIRECTIONS FOR USE: Combine the glaze on the
palette with tube oil paints or dry pigments. If you
intend to apply the glaze with your fingers or with
a rag, you will find the heavier consistency,
undiluted, more convenient. Thinned, the glaze
can be brushed on or used as a retouch varnish.
It dries in less than two days.

Damar resin, oil, balsam

PURPOSE: Brilliant gloss is one property of balsams;
Venice turpentine offers this characteristic, along
with a rather slow drying rate. The following
glaze dries in about three days.

INGREDIENTS	PARTS
Damar varnish (Varnish No. 1)	4
Sun thickened linseed oil	2
Venice turpentine	1

DIRECTIONS FOR MANUFACTURE: Combine heavy
bodied, sun thickened linseed oil with the other
ingredients at room temperature, shaking them
together in a clean bottle to insure complete
blending. Dilute the mixture with turpentine. To
accelerate the drying rate, substitute crystal clear
Canada balsam for Venice turpentine. Stand oil may
be substituted for sun thickened linseed oil.

DIRECTIONS FOR USE: Mix this glaze medium on
the palette with either tube oil colors or with dry
pigments. To apply the glaze with a rag or with the
fingers, use the glaze undiluted with turpentine.
The thinner solution is preferable for brushing or
for use as a retouch varnish. It is not advisable to
add siccatives or driers to glazes unless these
glazes are applied over gum or glue paintings.

Damar or mastic resin and wax

PURPOSE: Gum, glue, and casein paintings dry to a dull finish which many painters like to retain. For glazing or retouching these, or for dulling an oil painting, try this formula.

INGREDIENTS	PARTS
Damar varnish (Varnish No. 1)	
or	
Mastic varnish (Varnish No. 2)	1
Wax varnish (Varnish No. 21)	1

DIRECTIONS FOR MANUFACTURE: Combine the two ingredients and warm them in a double boiler or over an enclosed electric hotplate until the wax melts into the solution. Remove it from the heat and stir until the mixture cools to a heavy, semi-opaque liquid.

DIRECTIONS FOR USE: Mix the glaze on the palette with tube oil paints or with dry pigments. When this glaze medium is used with tube oil paints for final glaze layers, do not apply a final picture varnish. The glaze can be used liberally with dry pigments or as a painting medium. Because of the presence of wax, this addition to tube paints makes them thick and fast drying. The glaze medium *alone* dries in 15 minutes.

Mastic resin, oil, wax

PURPOSE: Like Glaze No. 4, this formula permits ample time for changing or manipulating, for it requires three days to dry. Poppy oil, clear and non-yellowing, is the retarder.

INGREDIENTS	PARTS
Mastic varnish (Varnish No. 2)	10
Poppy oil	20
Wax varnish (Varnish No. 21)	1

DIRECTIONS FOR MANUFACTURE: Combine all the ingredients and heat them over an enclosed electric hotplate until the wax melts into the solution. Remove from the heat and allow it to cool. Varnish No. 1 may be substituted for the mastic, and any form of linseed oil—raw, stand, or sun thickened— used instead of poppy oil.

DIRECTIONS FOR USE: Mix the glaze on the palette with tube oil colors or with dry pigments, and apply it very thinly, using a brush, a rag, or your fingers. The small amount of wax makes the glaze slightly thixotropic, but it does not cloud the dry film, or significantly reduce the gloss.

Balsam and oil

PURPOSE: Venice turpentine both heightens the gloss of linseed oil and slows down the drying time, permitting a soft fusion of color glazes.

INGREDIENTS	PARTS
Sun thickened linseed oil	*1*
Venice turpentine	*1*

DIRECTIONS FOR MANUFACTURE: This heavy-bodied oil, mixed at room temperature with the marvelously thick balsam, produces a clear, amber colored, and unctuous glaze medium which you may dilute with turpentine. Stand oil, heavy, may be substituted for sun thickened linseed oil, and Canada balsam used instead of Venice turpentine.

DIRECTIONS FOR USE: Mix the glaze on the palette with tube oil paints or with dry pigments. Apply it in very thin coats if you want it to dry within two days. Rub it onto the painting with your fingers or with a rag; if brushed on in heavier coats, the drying time will be extended by several days. Substituting Canada balsam for Venice turpentine will accelerate the drying time; it is not advisable to use a drier in final glaze layers except over gum or glue painting.

Verdigris, balsam, oil

PURPOSE: Verdigris (copper acetate) may have been the fabulous green pigment made famous by the paintings of the Van Eyck brothers. A. P. Laurie contends that balsams prevent harmful reaction between verdigris and other pigments, protecting the rich, clear, green hue.

INGREDIENTS	PARTS
Venice turpentine	*4*
Verdigris (copper acetate)	*1*
Stand oil, heavy	*1*
Ethyl ether	*1*

DIRECTIONS FOR MANUFACTURE: Warm the verdigris, powdered, with Venice turpentine until the verdigris dissolves in the balsam. After slightly cooling the solution, add the oil and stir together. When the mixture is completely cool, add the ether and cap the solution in a clean bottle. Turpentine can be added, gradually replacing the ether, which evaporates quickly.

DIRECTIONS FOR USE: This glaze performs best as a final coat, and may be brushed or rubbed on. Several coats of it applied over white will bring out the deep green hue, giving a cold color; for a warm green, verdigris must be applied over yellows. It dries in two or three hours.

Varnishes

Damar resin

PURPOSE: Almost universally used, damar resin—
either Batavia or Singapore—is sold in pale yellow
lumps, and serves many purposes: medium, glaze,
final picture varnish.

INGREDIENTS	PARTS
Damar lumps	*1*
Turpentine	*1*

DIRECTIONS FOR MANUFACTURE: Place the resin
lumps and turpentine in a tightly capped bottle,
agitating or turning daily until the resin has
dissolved, which will take a number of days. Allowing
the bottle to stand in warm sunshine accelerates
the process. This solution will have a thick, honey
consistency. If the damar lumps contain dirt or
foreign matter, strain the solution through
cheesecloth, or decant it into a clean bottle.

DIRECTIONS FOR USE: To use as a final varnish on
oil paintings, dilute the solution with an equal
quantity of turpentine; for varnishing egg tempera,
dilute with four times as much turpentine. The
original heavy consistency is ideal for use in
emulsifying or for combining with other ingredients
to make glazes or painting mediums. This damar
solution dries in one hour.

Mastic resin

PURPOSE: Nearly equal to damar for use in final varnishes, mastic is also sold in small lumps, which are known as *tears,* because they are exuded in this form.

INGREDIENTS	PARTS
Mastic tears	*1*
Turpentine or toluene	*2*

DIRECTIONS FOR MANUFACTURE: Mastic will not dissolve perfectly in turpentine unless the two are combined and heated. Warm them over an enclosed electric hotplate until the mastic melts, and stir thoroughly to achieve a complete solution. If toluene is used, the resin and solvent can be bottled and capped at room temperature for two or three days, then decanted into a clean bottle, leaving the residue of foreign matter behind. Benzene, methyl alcohol, and ethyl alcohol also dissolve mastic at room temperature.

DIRECTIONS FOR USE: Some authorities have expressed the opinion that mastic is not desirable to use in painting mediums (it dissolves too easily), but all agree that it is excellent as a final picture varnish. For use over oil paintings, dilute this solution with half its volume of solvent; for varnishing egg tempera, dilute it with four times its volume of solvent. It dries in one hour.

Copal resin

PURPOSE: The category of *fossil resins* includes copal resins as well as semi-precious amber. All are exceedingly hard and resistant to most solvents, but a pre-melting process renders them much more tractable. After copal has been given this treatment, it is called *run copal*.

INGREDIENTS	PARTS
Run copal lumps	*1*
Benzene	*4*
Turpentine	*3*

DIRECTIONS FOR MANUFACTURE: Crush the resin to a powder, then bottle it with the benzene until it is almost dissolved; it will not dissolve completely. Combine the turpentine with it and heat them together over an enclosed electric hotplate. The remaining resin will now dissolve. If the solution is further warmed or left uncapped, the volatile benzene will evaporate, leaving a copal-turpentine solution. Be very careful to avoid any open flame, for benzene is highly flammable.

DIRECTIONS FOR USE: Versatile and hard, copal solution can be used in combination with oils and resins as a painting medium; thinned for use as an isolating or final picture varnish; or thinned many times for use as a fixative. It dries in two hours.

Venice turpentine

PURPOSE: When you want to retouch and achieve a very thin, high gloss result, the sweet smelling balsams are made to order.

INGREDIENTS	PARTS
Venice turpentine	*1*
Turpentine	*2*

DIRECTIONS FOR MANUFACTURE: Venice turpentine can be obtained—highly purified and relatively expensive—from art supply houses. A cheaper and less pure form comes from wholesale houses (see *Sources*). In the less pure form, abietic acids form solids which encrust the sides of the container; but the clear balsam can be decanted and is perfectly satisfactory. Combine the two ingredients and stir into solution; warming in sunshine will help the dispersion.

DIRECTIONS FOR USE: For use in retouching, apply this varnish very thinly and paint into the coat while it is still wet. A thin coat dries within two hours to a very high gloss, but a final coat of picture varnish will equalize the differences of sheen.

Oil, damar, mastic resin

PURPOSE: A sixteenth century manuscript recommends this formula, whose nature lends itself to several uses as a varnish or painting medium.

INGREDIENTS	PARTS
Sun thickened linseed oil	*4*
Damar lumps	*2*
Mastic tears	*1*
Turpentine	*4*

DIRECTIONS FOR MANUFACTURE: Combine all the ingredients and heat them together over an enclosed electric hotplate. When the resins have melted, stir thoroughly and strain through muslin into a bottle. Stand oil, heavy, may be substituted for the sun thickened linseed oil.

DIRECTIONS FOR USE: Medieval wisdom notwithstanding, the high percentage of oil in this solution makes it undesirable for use as a final picture varnish over oil paintings; applied thinly over gum or glue paintings, however, it serves very well. This varnish also makes a good painting medium. It dries in less than two days.

Oil, mastic resin, balsam

PURPOSE: A four-hundred-year-old formula combines the major binding agents into a solution characterized as not too fast drying, which will function very well as a painting medium, as well as a varnish.

INGREDIENTS	PARTS
Sun thickened linseed oil, heavy	*4*
Mastic tears	*2*
Venice turpentine	*1*

DIRECTIONS FOR MANUFACTURE: Combine all the ingredients and heat them together over an enclosed electric hotplate until the mastic resin dissolves into the solution. Add gum spirits of turpentine to the hot solution if desired. Stand oil, heavy bodied, can be substituted for the sun thickened oil; damar lumps can be used instead of mastic; and Canada balsam can replace the Venice turpentine. The mixture will be fairly heavy and viscous.

DIRECTIONS FOR USE: The high percentage of oil makes this an excellent intermediary varnish, and a suitable painting medium with tube oil paints or with dry pigments. It is not recommended for use as a final varnish over oil paintings, but will serve well over gum or glue paintings. It dries in two days.

Oil and copal resin

PURPOSE: Highly insoluble, hard copal resins, if first combined with oil, will mix easily with solvents and other resins to make varnishes and mediums.

INGREDIENTS	PARTS
Run copal lumps	2
Raw linseed oil	3

DIRECTIONS FOR MANUFACTURE: A rather smelly affair, this procedure—so be sure to have excellent ventilation in the process. Heat the oil to a high temperature in one pan while you melt the copal resin in another. If the oil is cooked for about 45 minutes, it will thicken and darken—and will dry much more rapidly. After the resin melts, pour the hot oil into it, stirring until all is combined. Let the mixture cool, then pour it into a clean bottle. This solution is very thick. Heated stand oil may be substituted for cooked raw linseed oil.

DIRECTIONS FOR USE: This solution is a staple ingredient for mixture with many resins, balsams, and oils to make paint mediums and other varnishes. It imparts a thixotropic character to oil paints; and further diluted with turpentine, it can be used as an isolating varnish or as a final picture varnish. A thin coat dries in two days; a thick one requires nine days.

Damar resin and stand oil

PURPOSE: When time is short and you need to apply a final varnish, few formulas can exceed the performance of this varnish.

INGREDIENTS	PARTS
Damar varnish (Varnish No. 1)	*20*
Stand oil, heavy	*1*
Toluene	*1*

DIRECTIONS FOR MANUFACTURE: Combine the ingredients at room temperature in a clean bottle. Sun thickened linseed oil, or boiled stand oil (without the drier), made as directed under Size No. 6, can be substituted for stand oil. A lighter varnish can be made, too, by adding three or four parts of turpentine.

DIRECTIONS FOR USE: Brush on finished and dry paintings. This varnish, thinly applied, dries in 15 minutes. The oil contributes toughness to the film. Combined with tube oil paint, this varnish can be used as a painting medium.

Damar resin, stand oil, alcohol

PURPOSE: Soft resins and heavy bodied oils dry rapidly. The addition of toluene and alcohol accelerates the drying rate even more.

INGREDIENTS	PARTS
Damar varnish (Varnish No. 1)	10
Stand oil, heavy	2
Toluene	1
Alcohol	1

DIRECTIONS FOR MANUFACTURE: Combine all the ingredients at room temperature. The alcohol causes a very temporary cloudiness which disappears upon agitation. This varnish can be diluted further with turpentine.

DIRECTIONS FOR USE: A thin layer of resin-oil varnish will dry in about one hour. Apply it over oil, gum, glue, or casein paintings. For use as a painting medium, reduce the percentage of solvent as desired, and combine with tube oil paints or with dry pigments for glazing. Sun thickened linseed oil can be substituted for the stand oil.

Damar or mastic resin and wax

PURPOSE: The high gloss of a strong, final picture varnish can be muted by waxing—or by using a formula such as this one, which incorporates wax within it.

INGREDIENTS	PARTS
Damar varnish (Varnish No. 1)	
or	
Mastic varnish (Varnish No. 2)	1
Wax varnish (Varnish No. 21)	1

DIRECTIONS FOR MANUFACTURE: Heat the two ingredients together and stir thoroughly. When the wax has melted into the solution and has become clear, remove from the heat and let cool.

DIRECTIONS FOR USE: A multi-purpose varnish, this solution can be thinned for easy brushing; ground with dry pigments for use as paint; combined on the palette with the tube oil paint as a medium; and applied as a final picture varnish on oils, gouache, glue, egg tempera, and casein paintings. Because of the wax content, do not apply a non-wax varnish over this varnish when it is used as a painting medium. It dries in 15 minutes.

Damar resin and beeswax

PURPOSE: Wax combines well with damar resin to make a soft finish which is impervious to most harmful atmospheric effects, yet is easy to remove for cleaning or renewal.

INGREDIENTS	PARTS
Damar varnish (Varnish No. 1)	*4*
Beeswax	*2*
Turpentine	*1*

DIRECTIONS FOR MANUFACTURE: Combine all the ingredients and heat them over an enclosed electric hotplate until the wax dissolves into the solution. Into a clean bottle or jar, slowly pour the warm solution to prevent cracking or breaking the glass container.

DIRECTIONS FOR USE: This heavy, soft, multi-purpose paste can be applied directly with a rag to varnish any kind of painting and rubbed to a soft sheen after it has dried (in thirty minutes). To use resin-wax as a medium, mix it on the palette with tube oil paint or with dry pigments. Mixed with dry pigments it can be used for painting, but should be varnished only with another wax coating.

Mastic resin and oil

PURPOSE: A very small amount of oil can reduce the brittle quality of soft resins without greatly lengthening their drying rate.

INGREDIENTS	PARTS
Mastic tears	*32*
Turpentine	*16*
Raw linseed oil	*1*

DIRECTIONS FOR MANUFACTURE: Combine the resin with the solvent and heat them on an enclosed electric hotplate until the resin dissolves. Add the oil while the solution is hot. When cool enough, strain it into a clean bottle through muslin or layers of cheesecloth; or decant it when thoroughly cool. Use walnut or poppy oil instead of linseed to *lengthen* the drying time, and heavy bodied oils such as sun thickened linseed or stand oil to *shorten* drying time. A thin coat of this varnish dries in 15 minutes.

DIRECTIONS FOR USE: Dilute resin-oil with turpentine to make it thin enough to apply as a final picture varnish on any kind of painting; thin it extensively for use over egg tempera. This varnish can be used as a medium with oil paint.

Mastic resin and castor oil

PURPOSE: Even castor oil is good for something around the studio. A *very* small amount of this non-yellowing natural oil removes the brittleness of a mastic resin coat.

INGREDIENTS	PARTS
Mastic varnish (Varnish No. 2)	*19*
Castor oil	*1*

DIRECTIONS FOR MANUFACTURE: Combine the two ingredients at room temperature and shake them in a bottle to insure complete blending. Turpentine can be used for diluting.

DIRECTIONS FOR USE: This formula is best reserved for use *only* as a final picture varnish. In a heavy solution, castor oil is totally unsuitable for use in a varnish, for it requires weeks to dry. If you apply the varnish in very thin coats, however, they dry in 15 minutes. Apply two or more coats to insure a uniform gloss.

Damar resin, oil, balsam

PURPOSE: Soft resin and heavy bodied oil combine their fast drying rates in this varnish, but a balsam slows them down again, contributing to make a tough, high gloss coating.

INGREDIENTS	PARTS
Damar varnish (Varnish No. 1)	*4*
Sun thickened linseed oil	*2*
Venice turpentine	*1*

DIRECTIONS FOR MANUFACTURE: Combine all the ingredients at room temperature, and stir or shake together to completely blend them. Heavy-bodied stand oil can be substituted for sun thickened linseed oil, and Canada balsam used instead of Venice turpentine.

DIRECTIONS FOR USE: Dilute this varnish with turpentine to use it as a picture varnish on any kind of painting; very thinly diluted, it is suitable as an isolating varnish. For making paint or for use as a painting medium use it full strength. It combines well with tube oil paint and can be ground with dry pigments for laying on thin glazes. The varnish dries in three days. To reduce drying time, use Canada balsam instead of Venice turpentine.

Mastic resin, stand oil, balsam

PURPOSE: Recommended during the 1600's, this potpourri is characterized by toughness, high gloss, and very slow drying.

INGREDIENTS	PARTS
Mastic tears	*3*
Stand oil, heavy	*3*
Venice turpentine	*1*
Turpentine	*2*

DIRECTIONS FOR MANUFACTURE: On an enclosed electric hotplate, heat all the ingredients together until the mastic resin melts into solution. Stir thoroughly to insure complete blending. Upon cooling, this solution will be fairly heavy and viscous. It can be thinned with turpentine.

DIRECTIONS FOR USE: This formula is probably best suited for varnishing gum, glue, casein, or egg tempera. To apply this solution, thin it by adding an equal quantity (or more) of turpentine. This viscous solution can be used as a glazing medium; its slow drying permits leisurely manipulation of the glazes. It dries in about three days.

Balsam and oil

PURPOSE: Over 400 years ago, this varnish was recommended for application on wood that had been properly sized and sealed; assuredly it is one of the sweetest smelling of all varnishes.

INGREDIENTS	PARTS
Venice turpentine	*3*
Oil of spike lavender	*1*

DIRECTIONS FOR MANUFACTURE: Warm the ingredients together over heat and stir to blend them completely. Oil of spike lavender was once favored as a solvent; however, gum spirits of turpentine have proved to be superior in everything but fragrance. Canada balsam can be used instead of Venice turpentine, and turpentine substituted for the fragrant oil of spike lavender.

DIRECTIONS FOR USE: For use as a final picture varnish, thin with an equal volume of solvent—turpentine or lavender—and apply in very thin coats. Rendered extremely dilute by the addition of turpentine, this varnish makes a good isolating coat over underpaintings in gum, glue, or casein. Use it also as a medium or glaze in final coats of oil paint. It dries to a high gloss in 36 hours.

Balsam and sun thickened oil

PURPOSE: Use this varnish to retouch in oil over a dried oil paint surface. This formula delays drying for over a week, affording extensive opportunity to paint wet-in-wet.

INGREDIENTS	PARTS
Venice turpentine	4
Sun thickened linseed oil	1

DIRECTIONS FOR MANUFACTURE: Stir the two ingredients together over just enough heat to allow complete blending. Or bottle and place in hot sunshine to achieve the same results. This varnish is extremely heavy and viscous; a thin coat dries in 10 days. Stand oil can be substituted for sun thickened linseed oil, and either Canada balsam or Oregon balsam used instead of Venice turpentine.

DIRECTIONS FOR USE: For use as a final picture varnish, the heavy solution should be rubbed very thinly on the picture, or sufficiently diluted with turpentine to apply the varnish thinly with a brush. Canada balsam reduces the drying time to less than an hour, while Oregon balsam—a very dark material—permits the varnish to dry in little more than two hours.

Balsam, oil, mastic resin

PURPOSE: Linseed oil is needed to toughen the brilliant coat obtained by the use of balsams; the addition of a soft resin considerably reduces the drying time.

INGREDIENTS	PARTS
Venice turpentine	3
Raw linseed oil	3
Mastic tears	1

DIRECTIONS FOR MANUFACTURE: Melt the mastic tears over an electric hotplate. Then slowly stir in the other two ingredients. Continue to heat and stir until all the ingredients are thoroughly blended. When the varnish has cooled somewhat, strain it through muslin or cheesecloth into a clean bottle. This varnish is fairly heavy; a thin coat dries in three days. Heavy bodied oils, such as stand oil and sun thickened linseed, can be used instead of raw oil to reduce drying time.

DIRECTIONS FOR USE: The high percentage of oil makes this varnish more suitable for use on gum, glue, or casein paintings than as a final varnish on oils. In any case, dilute the solution with turpentine before applying it with a brush. This varnish can be used as a medium with tube oil paint.

Balsam and mastic resin

PURPOSE: Final picture varnishes should be clear and tough, and for convenience it is desirable that they dry rapidly. Balsams give clarity, and soft resins reduce drying time.

INGREDIENTS	PARTS
Venice turpentine	*2*
Mastic tears	*1*
Turpentine	*2*

DIRECTIONS FOR MANUFACTURE: Over an enclosed electric hotplate, heat the mastic resin until it has melted; then add the Venice turpentine and stir them together. Add the turpentine slowly in order to maintain the heat in the solution and stir all together until completely blended. Strain the cooled solution through muslin or cheesecloth into a clean bottle. Other balsams can be substituted for Venice turpentine, and damar lumps used instead of mastic tears.

DIRECTIONS FOR USE: As a picture varnish, use this varnish as is, or thin it slightly with turpentine. Thinned with its volume of turpentine, this varnish can be used as an isolating varnish; mixed in its original state with tube oil paint, it makes a good painting medium. It dries in one hour.

Balsam and copal resin

PURPOSE: The exceeding hardness of the fossil resin, copal, unites well with the clarity of balsam to produce an excellent medium and a reasonably fast drying picture varnish.

INGREDIENTS	PARTS
Venice turpentine	*3*
Run copal lumps	*2*

DIRECTIONS FOR MANUFACTURE: Place the copal resin over direct heat, for it melts at rather high temperatures. Add the Venice turpentine in a slow stream, and continue to heat the two ingredients, stirring them until they are completely blended. If this formula is intended for picture varnishing, add an equal volume of turpentine and stir it into the solution before you remove it from the heat.

DIRECTIONS FOR USE: Apply this varnish in thin coats over the dry painting. It can be used over all mediums except waxes and synthetic resins. The thixotropic character of copal resin, however, makes this varnish suitable for glazes and for use with either dry pigments or tube oil paint as a painting medium. It dries in four hours.

Beeswax

PURPOSE: Often the painter does not desire the high gloss of good picture varnishes. Rather than use weak, dull varnishes, it is preferable to soften the effect of the painting by applying wax over the surface.

INGREDIENTS	PARTS
Beeswax	*1*
Turpentine	*3*

DIRECTIONS FOR MANUFACTURE: Over an enclosed electric hotplate, heat both ingredients in a double boiler until the wax melts into solution with the turpentine. Remove from heat; stir from time to time as the solution cools to a very soft paste.

DIRECTIONS FOR USE: Beeswax, which has served for centuries to protect surfaces from moisture and gases, is invaluable in painting mediums. This varnish can be applied with a rag or a brush to make a very thin coat over the dried painting— over any paint. After the coat has dried, polish it with a soft cloth to give a smooth, low luster finish. Use this varnish in combination with dry pigments for encaustic, or with tube oil paints as a painting medium.

Ceresin

PURPOSE: An excellent substitute for beeswax is ceresin. It is best to use the very whitest, with no evident crystalline structure.

INGREDIENTS	PARTS
White ceresin wax	*1*
Toluene	*4*

DIRECTIONS FOR MANUFACTURE: Place the wax and toluene together in a capped bottle and allow them to dissolve into a very soft paste. Or heat the ingredients over an enclosed electric hotplate until the wax has melted into solution.

DIRECTIONS FOR USE: This paste can be used— as may beeswax varnish—to carry out encaustic painting techniques; as an additive to tube oil paint; and as a final protective coating. Brush or rub on the ceresin varnish with a rag; make as thin a coat as possible. After the solvent has evaporated, warm with a heat lamp and polish after the wax has cooled. This varnish is also good for coating metals and woods.

Combined waxes

PURPOSE: Waxes provide a bounty of virtues, permitting control of gloss as well as ease of removal when cleaning becomes necessary. Made as pastes with solvents, waxes can be kept on hand indefinitely, always ready for use.

INGREDIENTS	PARTS
Carnauba wax	2
Ceresin	2
Beeswax	1
Turpentine	15

DIRECTIONS FOR MANUFACTURE: Carnauba wax, perhaps the most precious of natural waxes, is shaken as a dust from the fronds of the carnauba palm tree. The hardest of the waxes, it gives the highest polish. Melt the ingredients together over an enclosed electric hotplate until the carnauba has dissolved into solution, and allow the liquid to cool until the solution can be poured into a can or bottle.

DIRECTIONS FOR USE: For use as a final protective coat, apply the paste thinly to any kind of thoroughly dry paint. When the solvent has evaporated, polish the wax with a soft cloth. This formula can be used effectively for grinding with dry pigments or with tube oil paints in an encaustic technique.

Beeswax emulsion

PURPOSE: This formula, which contains water, is practical for applying a thin coat of wax over paints or varnish which might be softened by a wax-in-solvent mixture.

INGREDIENTS	PARTS
Beeswax	*1*
Water	*8*
Ammonium carbonate	*1*

DIRECTIONS FOR MANUFACTURE: Determine the quantity of your total ingredients; use a pan three times that size in volume. Combine the beeswax and water and melt over heat. Stir in the ammonium carbonate a little at a time, for the solution foams up quickly when it is added. If the solution threatens to foam over the top, remove it from the heat— still stirring—until the foam subsides. About half the volume of water is lost in the manufacturing process. It can later be replaced with cold water.

DIRECTIONS FOR USE: Brush or rub on with a rag enough of the paste to leave a thin coat over oil paintings or on thoroughly dried gum, glue, or casein paintings. Do not work over a water soluble painting. When the water has evaporated, polish with a soft cloth. Beeswax emulsion may be used with varnishes and tube oil paints.

Glue

PURPOSE: An intermediate—or isolating—varnish for water base paints, glue permits the painter to "seal" one day's work, and begin the following work period without disturbing the underpainting.

INGREDIENTS

Leaf gelatine solution (Size No. 1)
 or
Hide glue solution (Size No. 3)

DIRECTIONS FOR MANUFACTURE: Make either of the size solutions according to directions. Hide glue solution is tougher than gelatine—but slower to make. Be careful not to cook or overheat the solution.

DIRECTIONS FOR USE: Basic in their usefulness, glue solutions are easy to manufacture and are fast drying. Apply the solution with a brush to tempera emulsion paintings or to gouache, as preparation for later painting. If you wish, you may apply the solution just before painting and then put on the new paint wet-in-wet. As a final varnish, this solution helps to bind and protect glue tempera and gum (gouache) paintings and thereby retain the dull finish.

Shellac and borax

PURPOSE: For isolating layers of gum, glue, and oil paint, a varnish soluble in alcohol is excellent. While alcohol is miscible with water, a dry coat of shellac rejects water.

INGREDIENTS	PARTS
Shellac, dry	2
Borax, powdered	1
Water	12

DIRECTIONS FOR MANUFACTURE: This varnish should be made fresh for use. When stored, the ingredients tend to separate. Combine the ingredients, using any form of shellac—brown lumps or bleached white—and heat to the boiling point. The shellac will have dissolved by this time. This solution can be further diluted with either water or methyl alcohol.

DIRECTIONS FOR USE: Best used as an intermediate (or isolating) varnish, this varnish should be applied in thin coats over gum, glue, or casein paintings. Although shellac is relatively brittle, thin coats allow the artist complete freedom to apply fresh layers of water or oil paint over them. For temporary purposes, this solution can be used as a varnish to seal water soluble color sketches.

Shellac and alcohol

PURPOSE: Famous and valued for its fast drying quality, shellac dissolved in alcohol can be used to advantage as an isolating varnish over distemper painting.

INGREDIENTS	PARTS
Shellac	*1*
Methyl alcohol	*5*

DIRECTIONS FOR MANUFACTURE: If clarity—or absence of any yellowness—if of great importance, use bleached white shellac. Otherwise, use the darker, higher priced lumps; they dissolve more completely. Denatured alcohol can be substituted for methyl alcohol (denatured alcohol is ethyl alcohol with a little dose of gasoline to ruin its taste), but methyl dissolves better. Combine the ingredients in a clean bottle. Two or three days are required to dissolve the shellac in the alcohol.

DIRECTIONS FOR USE: Brush or spray the shellac with an atomizer onto gum or glue tempera paintings. The coat will dry hard overnight and permit complete freedom to overpaint without fear of picking up the old paint layer. Thinned with ten times its volume of alcohol, this solution serves well as a fixative.

Acrylic

PURPOSE: When modern science develops a liquid of crystal clarity, and when two decades attest to its permanence, it is a pleasure to utilize such a miracle in painting.

INGREDIENTS

Acrylic *Select one from those listed under* Directory of Suppliers, Synthetic Resins.

DIRECTIONS FOR MANUFACTURE: If you use acrylic already in toluene or turpentine solution, dilute it with half again as much solvent. If you have the dry, powdered acrylic resin, combine it with twice its volume of toluene. Warming the combined ingredients, either in a double boiler or in hot sunshine, will accelerate its dissolution.

DIRECTIONS FOR USE: For use as a final picture varnish to apply over any painting medium, brush on the thinned solution of acrylic, or thin it further to make a solution light enough to spray. The same materials, in an equal proportion of resin to solvent, provide an excellent painting medium for mixing with tube oil paint. Even combined with the slower drying linseed oils, this varnish will reduce the drying time to one or two hours.

Fixatives

Mastic resin

PURPOSE: A good fixative must be light enough in solution to permit its being blown through an atomizer, and clear enough not to discolor appreciably the work being fixed.

INGREDIENTS	PARTS
Mastic varnish (Varnish No. 2)	1
Ethyl acetate or butyl alcohol	25

DIRECTIONS FOR MANUFACTURE: Combine the ingredients at room temperature. They should immediately form a pale yellow solution.

DIRECTIONS FOR USE: Good for chalk, charcoal, or pastel paintings, this fixative dries very rapidly. Place the work flat on the floor or on a table, and blow the fixative vapor slightly above it, at an angle, to prevent an accumulation of liquid on the surface of the picture. If one coat does not suffice, apply two or more, rather than one heavy coat.

Damar resin

PURPOSE: The pigment particles of pastels, chalks, and charcoal drawings must be stuck—or fixed— onto the surface without converting them into paint. The following formulas all perform well and offer a choice of solvents.

INGREDIENTS	PARTS
Damar varnish (Varnish No. 1)	*1*
Benzene	*25*

DIRECTIONS FOR MANUFACTURE: These volumes work out to be approximately two teaspoons of varnish to each cup of solvent. Combine them at room temperature.

DIRECTIONS FOR USE: See Fixative No. 1.

Balsam

PURPOSE: See Fixative No. 2.

INGREDIENTS	PARTS
Venice turpentine	*1*
Alcohol	*50*

DIRECTIONS FOR MANUFACTURE: Combine the
ingredients at room temperature. These volumes
are one teaspoonful of balsam to one cup of solvent.

DIRECTIONS FOR USE: See Fixative No. 1.

Rosin

PURPOSE: See Fixative No. 2.

INGREDIENTS	PARTS
White rosin	*1*
Benzene or alcohol	*50*

DIRECTIONS FOR MANUFACTURE: Combine the rosin and solvent in a bottle at room temperature. The alcohol will dissolve the rosin in about one hour; the benzene dissolves it in thirty minutes.

DIRECTIONS FOR USE: See Fixative No. 1.

Shellac

PURPOSE: See Fixative No. 2.

INGREDIENTS	PARTS
Shellac lumps	*1*
Methyl alcohol	*50*

DIRECTIONS FOR MANUFACTURE: Combine the ingredients at room temperature. Powdered white shellac may be used, but be sure to procure as fresh a stock as you can obtain; lump shellac—an excellent variety is called *Button Lac*—tends to preserve its freshness better than the finely powdered varieties.

DIRECTIONS FOR USE: See Fixative No. 1.

Collodion

PURPOSE: See Fixative No. 2.

INGREDIENTS	PARTS
Collodion, U.S.P.	*1*
Ethyl ether	*2*

DIRECTIONS FOR MANUFACTURE: These ingredients are extremely flammable. Keep them away from open flames. Combine them at room temperature.

DIRECTIONS FOR USE: See Fixative No. 1.

Acrylic

PURPOSE: See Fixative No. 2.

INGREDIENTS	PARTS
Acrylic varnish (Varnish No. 28)	*1*
Toluene	*20*

DIRECTIONS FOR MANUFACTURE: Combine the ingredients at room temperature.

DIRECTIONS FOR USE: See Fixative No. 1.

Gelatine

PURPOSE: See Fixative No. 2.

INGREDIENTS	PARTS
Leaf gelatine	*4 leaves*
Water	*½ pint*
Alcohol	*½ pint*

DIRECTIONS FOR MANUFACTURE: Warm the gelatine and water until the gelatine dissolves completely; then add the alcohol. This solution is good for varnishing gouache paintings. When it has dried, it can be toughened by spraying a 4% formaldehyde solution over it.

DIRECTIONS FOR USE: See Fixative No. 1.

Egg yolk

PURPOSE: See Fixative No. 2.

INGREDIENTS	PARTS
Egg yolk	1
Water	34

DIRECTIONS FOR MANUFACTURE: See Medium No. 24 for instructions on separating the egg yolk and draining its fluid. Combine the yolk and water and shake well. This fixative is good to use with a brush as an isolating varnish.

DIRECTIONS FOR USE: See Fixative No. 1.

Skim milk

PURPOSE: See Fixative No. 2.

INGREDIENTS

Skim milk

DIRECTIONS FOR USE: One of the oldest methods of fixing drawings or pastel paintings is to spray pure skim milk on them, obtaining a vaporous casein coating in the process.

Adhesives

Beeswax and mastic resin

PURPOSE: Destruction of oil paintings frequently begins from the back, where dampness can attack through the ground. This formula is designed to seal the canvas against such an attack.

INGREDIENTS	PARTS
Beeswax	*3*
Mastic tears	*1*

DIRECTIONS FOR MANUFACTURE: Combine and heat the two ingredients until the resin melts into the wax. If there is foreign matter in the resin, decant the clear solution into another container or strain it through cheesecloth.

DIRECTIONS FOR USE: Place the painting face down and apply the hot mixture to it with a palette knife or a putty knife, scraping the coating to cover the entire surface thinly. Over this layer of adhesive, lay strips of untreated linen canvas—the thinner the better—until the surface is completely covered. Apply a fresh coat of adhesive over the linen strips and press them firmly onto the original canvas back. If necessary, heat the knife or spatula in order to insure perfect bonding. Leave the painting alone until the resin and wax mixture has set and cooled. This treatment protects the back of the canvas from moisture penetration.

Wheat paste

PURPOSE: To mount prints, maps, or any reproductions printed on paper, use wheat paste, a substance which allows simple and rapid working without making an irrevocable bond.

INGREDIENTS	PARTS
Flour (wheat)	*1*
Water	*10*
Alum	*See below*

DIRECTIONS FOR MANUFACTURE: To the flour, add enough cold water to make a slurry (a thin batter), stirring until all lumps disintegrate. This can be done easily if you allow the slurry to stand for about an hour. Then put the slurry into a double boiler; boil the remaining water and stir it into the paste; continue to stir until the paste thickens. For each pint of paste, add ¼ teaspoon of alum. This ingredient makes the paste dry to a harder coat. To make the paste mildew resistant, add ½ teaspoon of 40% formaldehyde to each pint of paste.

DIRECTIONS FOR USE: Brush a very thin coat of paste onto the back of the paper to be mounted; press the paper onto the mount, wiping from the center toward the edges to insure complete contact. If necessary, cover with wax paper and place a weight on it until the paste has dried.

184

Hide glue, paste, balsam

PURPOSE: When a canvas support becomes weak from age or inherent defect, it may be strengthened by bonding (relining) it to a new, strong linen canvas.

INGREDIENTS	PARTS
Hide glue solution (Paint No. 28)	*18*
Starch paste (Size No. 7)	*3*
Venice turpentine	*2*

DIRECTIONS FOR MANUFACTURE: Stir the glue and paste together until thoroughly blended. Although you must warm the glue until it dissolves in order to do this, don't warm it more than necessary. Pour the Venice turpentine into the paste and glue solution, stirring vigorously to break down the balsam globules.

DIRECTIONS FOR USE: Stretch and size the new linen larger than the dimensions of the oil painting that is being relined. Apply the warm adhesive both to the new linen and to the back of the old painting, then press the new onto the back of the old. Firmly rub the whole surface to insure complete contact. After a few days, iron the back of the new linen with a heavy tailor's iron to make a perfect bond.

Paste and balsam

PURPOSE: This traditional relining adhesive joins the fast setting, thixotropic starch paste with Venice turpentine.

INGREDIENTS	PARTS
Starch paste (Size No. 7)	5
Venice turpentine	1

DIRECTIONS FOR MANUFACTURE: Follow the directions for making Size No. 7, first wetting the starch with cold water and then stirring it slowly into boiling water until the thickened paste becomes cool. Squeeze the paste through thicknesses of cheesecloth to remove lumps, and stir in the Venice turpentine to break up the balsam globules finely.

DIRECTIONS FOR USE: The new linen should be stretched and sized to dimensions larger than those of the painting to be relined, and stretched gently rather than tightly. Apply the adhesive with a stiff brush to the back of the old canvas and to the face of the new. Press the two together and rub the back of the new canvas firmly to insure complete contact between the two.

Lead white and oil

PURPOSE: This relining formula nearly duplicates those recommended for making painting grounds and utilizes on the back of the canvas an adhesive closely resembling that already applied to the front.

INGREDIENTS

Lead white, dry pigment
Boiled linseed oil (Size No. 6)

DIRECTIONS FOR MANUFACTURE: Follow the directions given for Size No. 6 to make the boiled linseed oil. Place the dry lead white pigment on a marble or glass slab, working with only a tablespoonful or so at a time. Add a small amount of oil and grind until the mixture is fluid; then add more dry pigment and continue grinding. Use a glass muller for large amounts, or a palette knife for small quantities, and continue to grind the paste until you have used all the pigment. Remember that a nearly unworkable, stiff pigment becomes much more fluid with continued grinding.

DIRECTIONS FOR USE: Apply this mixture to the back of the old canvas and to the front of the new canvas which has been gently stretched and sized. Press them firmly together and rub out any excess adhesive. Let the canvas dry several months away from direct heat.

Rosin, oil, wax

PURPOSE: The addition of wax gives a relining adhesive many times more resistance to moisture penetration and combines easily with the traditional rosin and oil mixture.

INGREDIENTS	PARTS
White rosin	*10*
Boiled linseed oil (see Size No. 6)	*2*
Turpentine	*3*
Beeswax	*1*

DIRECTIONS FOR MANUFACTURE: Combine the rosin and turpentine and heat in a double boiler until the rosin has dissolved. Add the beeswax, melt it into solution, then stir in the boiled linseed oil. Blend them all together over heat, then set the mixture aside to cool.

DIRECTIONS FOR USE: This formula makes a very thick, unctuous paste. Size the new, gently stretched linen with glue, adding a little alum solution (one part alum lumps, 10 parts water) to the glue size. With a palette knife or with a very stiff brush, coat the adhesive on the back of the old linen and on the front of the new. Press the two together, firmly rubbing the entire surface to insure complete contact. Let the canvas dry several months away from direct heat.

Notes

NOTE NO. 1

Siccatives or driers

When using cobalt linoleate, add no more than
20 drops of drier to each six ounces of medium
or varnish, or 50 drops per pint. Most authorities
caution against using driers of any kind, and it
is certainly not advisable to use them in the top
layers of paint, glaze, or varnish. For accelerating
the drying time of these layers, select formulas
composed of naturally fast drying oils or resins,
or paint with pigments which accelerate the
drying rate.

NOTE NO. 2

Casein paint on plaster

Casein solution, mixed with dry pigments, can
be painted on wet lime water or on fresh lime
plaster to form a hard, weather resistant coating
on exposed outdoor surfaces. Use only lime-proof
pigments.

NOTE NO. 3

Lime fresco

Refer to the special texts in the bibliography for
complete instructions on executing true lime fresco.
Mix lime-proof dry pigments with distilled water
to form soft pastes, and paint these thinly and

directly onto the freshly applied lime plaster. Wait until the surface water has drawn into the plaster before you brush the paint on; apply it in bold, cross-hatching technique and never work it over with successive brushstrokes.

NOTE NO. 4

Quick drying white

Combine a mixture of egg yolk and lead white pigment with stiff lead white oil paint, grinding a little egg-white lead mixture into the oil paint. The egg stiffens the oil paint and makes it set quickly and dry hard.

NOTE NO. 5

Final picture varnishes

Make sure the painting is clean and free from dust before you apply the varnish. A quick, light cleaning with a linen cloth soaked in turpentine should suffice. If necessary, clean it with soap emulsion and water; remove all vestiges of soap afterwards and let it dry thoroughly. Apply the varnish as thinly as possible and allow the painting to dry, resting flat, away from dust. If the dry

coat is not uniformly shiny, apply a second coat.
Strong varnish—the most desirable—is glossy.
To reduce the gloss, apply a beeswax formula
and polish.

NOTE NO. 6

Opaque glazes

Though opaque glaze sounds like a contradiction
in terms, it really works. Mix just enough lead
white (or Cremnitz or flake) with your glaze to
render the glaze opaque. The immediate effect
of this kind of glazing looks exactly like direct—
or alla prima—painting. Within three or more
years, the inevitable alteration of the pigment
particles in the glaze layers will occur, allowing
light to penetrate them, producing an opalescent
quality in the glaze color. As in the use of any
glazes, the *entire* painting should be glazed to some
extent to maintain an optical unity.

NOTE NO. 7

Picture placement

As Max Doerner expresses it, glazes "eat" light,
and therefore need a great deal of it in order to
display their full charm. For this reason, either
hang such paintings where natural light will fall

upon them, or arrange artificial light to illuminate the painting. Lighting styles change along with all others; although picture lamps are not admired by everyone, one of the most effective and delightful rooms I've seen was illuminated by the paintings hanging on its walls, each painting glowing under its own picture lamp. Opaque paintings can utilize the most fugitive lighting and can be hung satisfactorily in poorly lighted areas.

NOTE NO. 8

Glazes and dimension

By a judicious use of glazes, the painter can control to some extent the illusion of three dimensional space. The more heavily an area is glazed, the more it tends to recede; opaque surfaces, by contrast, appear to advance. By controlling the degree to which he glazes the various areas, the painter can push back or bring forward these areas.

NOTE NO. 9

Siccative oil

PURPOSE: One of the early methods of accelerating the drying rate of glazes and paint mediums was to cook a lead pigment in oil, then add a little of this drying agent to the medium.

INGREDIENTS	PARTS
Raw oil (linseed, poppy, or nut)	8
White lead, dry pigment	1

DIRECTIONS FOR MANUFACTURE: In an enameled pan, simmer the oil over heat, stirring in small amounts of the lead and allowing it to dissolve before adding more. This process, which takes about half an hour, turns the clear oil very dark. Let it cool, then decant it into a clean bottle. The oil dries in 10 to 15 hours.

DIRECTIONS FOR USE: On the palette, add and thoroughly mix small amounts of this oil with tube oil glazes or those made with dry pigments.

NOTE NO. 10

Toned grounds (imprimatura)

PURPOSE: Brilliant white is probably the most popular ground. However, a thin coat of color (an imprimatura) over this white ground allows the painter to develop his values by whitening and darkening this middle tone, thereby achieving the basic overall values of his painting in the imprimatura, or color wash.

DIRECTIONS FOR USE: Choose a varnish or fixative solution which dissolves with other solvents than those used in the painting. Combine the imprimatura with the underpainting wherever the value—or drawing—is to dominate. Make the imprimatura very thin and translucent in order to retain the benefits of the white ground's reflecting power; also keep the underpainting thin. The highest

value can be achieved by scraping or rubbing through the imprimatura to expose the white ground. If you wish, you may complete the imprimatura and underpainting, let them dry, and then isolate the whole treatment with a fixative or with a varnish recommended for this purpose.

NOTE NO. 11

Rapid drying oil for underpainting

An underpainting should be *lean*—that is it should have a ratio of a large amount of pigment to a small amount of binder. If the underpaint is oil, it is easy to over-dilute and weaken it in the process of making it lean. One method to combat this diluting process is to grind white lead *dry* pigment (rather than white lead tube color) into the tube oil colors, and use only enough solvent to make the paint workable. White lead accelerates the drying rate of oil paint; where the painting is being applied to a white lead ground, white lead in your colors will help make a perfect bond between paint and ground. After the underpainting is finished and dry, use a retouch or an isolating varnish to coat the underpainting before you apply subsequent layers.

NOTE NO. 12

Making a ground accept oil paint

Sometimes a ground resists accepting oil paint— the oil draws back into itself and may even form

beads, as though it were being applied to a wet surface. Several devices can be employed to remedy this situation. Take pumice, chalk, or gypsum, and scrub the ground with it to remove the smooth surface. Or rub the ground with a slice of onion, potato, or diluted household ammonia. Another device is to wipe the ground with alcohol. Sometimes this condition occurs between an old, dried oil surface and an application of fresh oil paint. While the above mentioned devices can be used in this second case, the application of a retouch varnish best remedies the problem.

NOTE NO. 13

Wetting agent

When making glue, gesso, or gum solutions, the painter may whip in too much air, and then find that the air bubbles interfere with his ability to apply a flawlessly smooth coating. Often these bubbles dissipate after being allowed to stand for half an hour or so. When you must remove them immediately, stir into the mixture an oxgall solution or a small amount of oxgall which has been ground into a paste with water.

NOTE NO. 14

Renewing old varnish or paint

Combine Copaiba balsam with an equal part of turpentine, and brush on the solution very thinly.

Let the coat dry. If its gloss is not even throughout, apply more coats of the mixture. This coat can be painted into with retouch varnishes, or it can be allowed to dry thoroughly before varnishing with final picture varnish.

NOTE NO. 15

To harden coats or to resist mildew

Spray formaldehyde, in a 4% solution, onto the surface to be hardened or made resistant to mildew—sizing, paint, canvas, or paper. Formaldehyle is particularly useful for toughening glue surfaces and protecting them from mold or mildew. A standard 37% formaldehyde solution can be obtained from most drugstores; one part added to 10 parts of water produces the proper solution.

NOTE NO. 16

Cleaners

TEMPERA OR GOUACHE: To clean egg tempera or gouache paintings, rub the surface with bread crumbs or with a kneaded eraser. Do not use cleaning solutions.

VARNISHED SURFACES: For a light cleaning of varnished surfaces, wipe with a rag dampened

in turpentine or alcohol. A combination of turpentine and Copaiba balsam (five parts turpentine, one part balsam) reduces the cutting action of the solvent, making it safer to use—less likely to damage the surface of the painting.

FRESCO: Fresco requires gentle treatment even when the lime skin is still strong and intact. Try distilled water alone, or non-greasy bread crumbs of heavy bread. Remove stubborn dirt with equal parts of Castile soap solution, distilled water, and ethyl acetate. This solution must be kept agitated in order to combine the solvent with the soap.

STUBBORN DIRT: Ammonia water can be used directly—but sparingly—on stubborn areas of dirt, or it can be added to turpentine or alcohol to make them more effective. Household ammonia can be rubbed on gently to remove grease from paper.

WATERCOLOR: For cleaning or restoring faded or yellowed watercolors, fill a basin larger than the picture with water and borax (60 parts water, 1 part borax). Soak the picture in this solution for half a minute, then remove and lay the paper on a sheet of clean glass. Dry it away from direct heat. This treatment should restore some of the brightness of the colors. Where a print or a watercolor has yellowed outside the printed or painted area, blot the yellowed area with a blotter soaked in peroxide for a few seconds at a time. If, after drying, the spot persists, repeat the treatment.

Patches and tears in paper

To repair tiny holes in paper or to cement torn
fibers, take a piece of (or scrapings from) the
same paper; soak it and combine the resulting
paste with a little starch paste. Lay the paper flat
and dampen the edges of the hole or tear sufficiently
to accept the paste and fiber. Apply it carefully and
let it dry.

To remove creases, dampen the paper
thoroughly between wet blotters and leave it to
dry flat on a wet plate of glass.

NOTE NO. 18

Studio equipment

Whipping up most formulas contained in this
volume requires a minimum of equipment.
Exceptions have been noted in the individual
formulas. There are many items which have
proved immensely useful, though commonplace
and easily acquired. The order in which these
items are listed has nothing at all to do with their
importance, for all of them are useful.

HEATING UNIT: I strongly advise you to purchase
a high quality electric hotplate in which the

heating elements have been cast into the solid metal plate, and are therefore enclosed for safety. Buy one which generates 1000 watts and has a control that permits at least three settings of temperature. Glues, pastes, and the like can be prepared over gas flames without danger; but when solvents are involved, use only the enclosed electric heat source.

THERMOMETER: A thermometer, graded in both fahrenheit and centigrade readings, is very handy for checking the hotplate capacities. Scientific supply houses sell them. My thermometer permits readings from +20 F. up to +680 F. along with the corresponding approximations of −10 C. up to +360 C.

SOLVENTS: If you have sufficiently safe storage areas available, a selection of solvents is most convenient; keep them tightly stoppered and well away from heat and curious youngsters. Ethyl alcohol, pure or denatured, pure gum spirits of turpentine, toluene, benzene, ethyl ether, and morpholine (technical grade) are all useful and permit you to choose between the hydrocarbon and alcohol families. All of these are reasonably priced and should be bought in gallon containers, except for the last two. Ethyl ether is available at hobby shops, where it is sold for fueling model engines. Morpholine, however, is a rather expensive item, useful primarily for cleaning or removing stubborn layers or stains from oil paintings, where it must be manipulated with the greatest care.

CONTAINERS: You do not need expensive pans and utensils, for the preparation of many formulas makes a mess too disagreeable and stubborn to remove from these containers. On most occasions, your most valuable and expendable vessel is the everyday tin can—rescued from the kitchen, rinsed thoroughly, and dried. Save all sizes, fitting small ones inside large ones for double boilers, and use plastic lidded coffee tins to store dry materials neatly.

Useful, too, are inexpensive sets of enameled pans which you can purchase at the dime store. For stirring or mixing, stainless steel spoons are excellent and cheaply procured from the same store. For storing formulas—liquids in particular—baby food jars are splendid, for they have tightly fitted lids. If you want a more professional or larger container, visit your drug supply house, where round or square, clear or green bottles can be bought for very little. It is a good practice to glue on labels as soon as a formula has been bottled; in postponing this small chore, you may forget completely what the bottle contains.

RAGS AND TISSUES: Paper towels are very practical, but cloth rags are even more convenient to wipe or clean the studio. Clean, white, laundered rags can be bought from many commercial laundries (have you wondered about missing sheets and shirts?) or from janitor supply firms. Muslins, thin or sheer linens, and cheesecloth all ease the task of straining or filtering mixtures through various sizes of funnels. Ridiculously convenient and

economical are the little folded sheets of toilet tissues which are designed to be dispensed by metal containers in washrooms; two layers will wrap up palette scrapings with a minimum of fuss.

ODDS AND ENDS: Good quality palette knives serve multiple purposes as stirrers, grinders of pigments, and to manipulate paints on the palette. Keep several of them—straight and tapered—on hand. Pliers, tongs, or grippers (of various sizes and designs) aid in lifting containers filled with hot mixtures, and prevent many a disaster resulting from dropping a too-hot-for-comfort container.

NOTE NO. 19

Substitutes

AMBER: Amber is frequently listed as an ingredient in medieval formulas for making tough, weather-resistant varnishes. But many authorities believe that copal resins were confused at that time with fossil amber resins; today, copal is used to make "amber" varnishes.

AMMONIUM CARBONATE: Wherever water resistance is not a paramount factor, you may replace ammonium carbonate with household ammonia; it may increase the water percentage.

BEESWAX: You will rarely need a substitute for beeswax, for it is available nearly everywhere.

However, paraffin or ceresin, having similar characteristics, may be used in its stead.

BODIED OILS: Bodied oils (or heavy bodied oils) include sun thickened linseed oil, stand oil, and boiled linseed oil. Where any one of these is listed in a formula, frequently one of the others will serve, although boiled oil tends to "skin" more rapidly than do the others.

CANADA BALSAM: Canada balsam is truly a marvelous substance, and precious in cost. It may be replaced by Oregon balsam, a much cheaper article which is excellent if you don't object to its deeper color.

CASEIN, POWDERED: Use freshly manufactured casein to obtain the full strength that casein can offer. If it is not available buy dry curd cheese—available at many delicatessens—and use as suggested under Paint No. 34.

CERESIN: This is a natural wax obtained from the waxy mineral resin ozocerite. Ceresin is pure white, odorless, and non-crystalline. Its best substitute is high quality paraffin, which it closely resembles both in appearance and characteristics. The best paraffin is also pure white—being a fine microcrystalline wax—and not translucent.

CHINESE WHITE: In silver-point drawing, frequently a painter needs to coat his own paper to achieve the beautiful grays of the medium; Chinese white, a material often prescribed to make the coating,

is simply zinc white, or zinc oxide. Titanium white serves well also.

COPAL, OIL VARNISH: Varnish No. 7 may be made by the painter, but at some sacrifice of time and energy. The products sold under the name of *Copal Concentrate* (Permanent Pigments) and *Amber Varnish* (Winsor & Newton) may be used where Varnish No. 7 is called for.

CREMNITZ WHITE: White lead is also sold as *flake white* and *cremnitz white*; cremnitz white is considered superior in quality to the other two. All three are lead whites which may be interchanged where desired.

GROUND NO. 8: Permanent Pigments manufactures an excellent gesso called *Gesso Ground-Dry Mixture*, which stores well and has the glue and pigment already combined. All you do is add water. This product may be substituted throughout for Ground No. 8.

LEAD WHITE IN OIL: For grounds which require stiff lead white in oil, use ready-made heavy pastes of lead in oil; these are available under the trade-mark of *Dutch Boy*, and from Permanent Pigments and Utrecht Linens in pint cans and larger. If a manufactured oil white is too oily, leave it on layers of brown wrapping paper for several days to absorb the excess oil.

OIL OF SPIKE LAVENDER: During the Middle Ages this lovely solvent—almost a perfume—was a major

item used by artists and artisans; today pure gum spirits of turpentine serve in its stead. Turpentine, which is superior to oil of spike lavender in nearly every way except in odor, can replace it in all formulas.

PLASTER OF PARIS: Plaster of Paris, available almost everywhere, is often sold as *molding plaster*. Either the fast setting or slow setting variety will do.

TURPENTINE: Throughout this book the word *turpentine* means *pure gum spirits of turpentine*— not *steam-distilled*. While the latter may be used, it does not possess exactly the same properties; it *does* possess a strangely penetrating odor which is highly offensive to many people. These differences between 'steam-distilled' and 'pure gum spirits' are denied flatly by a major producer of turpentine, who declares that both are packaged from the same barrel.

VENICE TURPENTINE: Wherever it is possible to do so, use Canada balsam instead of Venice turpentine. Canada balsam is water-clear, dries far more rapidly than Venice turpentine, and yet retains its fragrant oleo-resinous odor. Unfortunately, it is far more expensive than Venice turpentine.

Tables

The drying times given in Tables 1 and 2 were established by smearing a thin (or thick) film of the material on a plate of glass, out of direct sunlight; no attempt was made to control such normal variables as temperature and humidity. A film will dry faster on an absorbent surface than on glass; but glass provides a constant not obtainable from absorbent surfaces.

The climatic conditions of the testing area should also be considered: El Paso (my home) is in a semi-arid region; its temperatures range from 60° F. to 110° F. during the summer months, when some of these tests were made. The relative humidity fluctuated between 3% and 90%— a tremendous variation. Where listed drying times disagree with the reader's experience, remember these differences. Pigments combined with mediums and glazes further change the drying rates, as pointed out in Table 7. Table 5 is intended to provide the painter with a point of departure rather than with a set formula ratio of pigment to oil. Here again, the conditions under which paints are manufactured control the precise formulation. For the manufacturer of paint, these figures would be useless; he uses far more pigment than does the painter, working with a muller or palette knife. Additives, too, permit the manufacturer to achieve far different paint handling quality than the studio worker can effect.

When you make paint, start with a small amount of dry pigment; add just enough oil to barely absorb the pigment; work the two together until a stiff and barely manageable paint forms; then continue to work the mass a while longer. Add more oil or pigment as needed, until the amount of paint is sufficient. The more you grind or work the paint, the more fluid it will become. Remember that bodied oils absorb more pigment than raw oils; use less stand oil or sun thickened linseed oil, therefore, than the figures recommended in the table.

TABLE 1

Drying time of oils, resins, and balsams

		Drying time
OILS	*Linseed oil, raw, thin coat*	3 days
	Linseed oil, raw, thick coat	10 days or more
	Poppy oil, raw	5 days
	Stand oil, thin coat	2 days
	Stand oil, thick coat	10 days
	Sun thickened linseed oil, thin coat	2 days
	Sun thickened linseed oil, thick coat	9 days
	Walnut oil, raw	5 days
RESINS	*Acrylic (Medium No. 27)*	30 minutes
	Copal (Varnish No. 3)	2 hours
	Damar (Varnish No. 1)	1 hour
	Elemi resin, soft	1 hour
	Mastic (Varnish No. 2)	1 hour
BALSAMS	*Canada, pure*	1–2 hours
	Oregon fir, pure	1–2 hours
	Venice turpentine, pure	3 days

TABLE 2

Drying time of mediums, glazes, and varnishes

Mediums		Glazes		Varnishes	
No.	Drying time	No.	Drying time	No.	Drying time
1	1½–2 days	1	1 hour	1	1 hour
2	2 days	2	2 days	2	1 hour
3	1½ days	3	1 hour	3	2 hours
4	3 days	4	1½ days	4	2 hours
5	2 days	5	3 days	5	1½ days
6	1 hour	6	30 minutes	6	2 days
7	30 minutes	7	3 days or more	7	2 days (thin)
8	30 minutes	8	2 days	8	15 minutes
9	30 minutes	9	2–3 hours	9	1 hour
10	3 days			10	15 minutes
11	1½ days			11	30 minutes
12	30 minutes			12	15 minutes
13	2 days			13	15 minutes
14	15 minutes			14	3 days
15	1½ hours			15	3 days
16	1½ days			16	1½ days
17	3 days			17	10 days
18	30 minutes			18	3 days
19	30 minutes			19	1 hour
20	30 minutes			20	4 hours
21	30 minutes			21	30 minutes
22	30 minutes			22	30 minutes
23	1 hour			23	30 minutes
24	3 hours			24	30 minutes
25	15 minutes			25	1 hour
26	5 minutes			26	15–30 minutes
27	30 minutes			27	30 minutes
				28	1 hour

TABLE 3

Melting points and solvents of resins

Resin	Melting point		Solvent
	C.	F.	
Amber	250	482	Partially soluble in benzene, methyl alcohol, or turpentine
Canada balsam			Turpentine, ethyl acetate
Copaiba balsam			Turpentine or benzene
Copal, Congo	180	356	Diacetone alcohol. Partially soluble in turpentine or methyl alcohol
Copal, Manilla	120	248	Acetone, diacetone alcohol. Partially soluble in turpentine, butyl alcohol
Copal, Sierra Leone	130	266	Partially soluble in methyl alcohol, ether, or benzene
Damar, Batavia	80	176	Turpentine, benzene, ethyl alcohol, or ether
Elemi resin	77	170	Toluene, ethyl alcohol, or butyl alcohol
Mastic	95	203	Toluene, benzene, methyl alcohol, ethyl alcohol, or ether
Rosin (colophony)	120	248	All solvents
Sandarac	135	275	Ethyl alcohol, butyl alcohol, acetone, or ethyl acetate
Shellac	115	239	Methyl alcohol (best), ethyl alcohol, or butyl alcohol
Turpentine, Venice			Turpentine, benzene, alcohol, chloroform

TABLE 4

Melting points of waxes

Wax	Melting point		Wax	Melting point	
	C.	F.		C.	F.
Beeswax	62	144	Chinese insect	80	176
Candelilla	65	149	Japan	50	122
Carnauba	84	183	Montan, refined	77	170
Ceresin	65	149	Spermaceti	41	106

TABLE 5

Boiling points and flash points of solvents

Solvent	Boiling point		Flash point	
	C.	F.	C.	F.
Acetone	56	133	−9	15
Benzene	80	176	−15	5
Butyl alcohol	117	243	46	117
Chloroform	61	142	none	
Diacetone alcohol	169	335	68	155
Ethyl acetate	77	170	4	40
Ethyl alcohol	78	172	21	70
Ethyl ether	34	93	−20	−4
Gasoline	40	104	0	32
Methyl alcohol	64	147	15	59
Mineral spirit	150	302	40	104
Naphtha (petroleum)	90	194	10	50
Toluene	110	230	6	43
Turpentine (gum spirits)	155	279	34	93

NOTES: Denatured alcohol is ethyl alcohol which has been rendered unfit for human consumption by the addition of gasoline or kerosene. Flash point indicates the temperature at which the vapor rising from the solvent will ignite from an exposed flame. It is advisable at all times to keep solvents away from heat and to be extremely cautious about smoking cigarettes or striking matches while handling solvents.

TABLE 6

Ratios of dry pigment to oil

The table below specifies the amount of dry pigment you need for each unit of oil. The left-hand column names the pigment. The middle column lists in volume measurements the ratio of pigment to oil: for one volume of oil, use the following volume of pigment. The right-hand column lists in weight measurements the ratio of pigment to oil: for one weight unit of oil, use the following weight unit of pigment.

Dry pigment	Pigment volume	Pigment weight
Alizarin crimson	2.3	0.66
Burnt sienna	2.2	1.66
Burnt umber	1.9	1.33
Cadmium orange	3.5	3.0
Cadmium red	3.0	3.0
Cadmium yellow	3.5	3.0
Cerulean blue	2.0	2.5
Chromium oxide green	2.0	3.4
Cobalt blue	1.0	1.66
Green earth	1.2	1.0
Indian red	4.0	3.66
Ivory black	1.1	1.0
Mars yellow	3.4	1.6
Naples yellow	2.0	4.0
Phthalocyanine blue	1.0	0.4
Phthalocyanine green	0.9	0.64
Prussian blue	2.8	1.14
Raw sienna	2.0	1.77
Raw umber	1.8	1.28
Titanium dioxide	1.8	2.0
Ultramarine blue	3.5	2.3
Venetian red	2.2	1.78
Viridian	1.8	1.11
White lead (flake white)	6.0	7.5
Yellow ochre	3.0	2.0
Zinc oxide	5.4	5.0

TABLE 7

Lime-proof pigments

WHITE	*Lime putty*	BLUE	*Cerulean*
	Barium sulphate		*Cobalt*
BLACK	*Ivory black*		*Ultramarine*
	Vine black	VIOLET	*Mars violet*
	Charcoal black		*Ultramarine red*
YELLOW	*Cadmiums*	RED	*Cadmiums*
	Ochres		*Earth or Oxide (Venetian,*
	Mars colors		*Indian, English, etc.)*
	Naples		
BROWN	*Umbers*	GREEN	*Viridian*
	Siennas		*Chromium oxide*
			Green earth
			Cobalt

TABLE 8

Drying characteristics of pigments

To achieve rapid drying glaze layers, choose pigments rated below as fast, as well as rapid drying oils and resins. By carefully matching pigments and resins one can control to a large degree the drying rates of mediums, glazes, and paints.

Fast	Medium	Slow	Very slow
Umbers	Cobalts	Green earth	Ivory black
Burnt sienna	Oxides	Alizarin	Cadmiums
Flake white	Raw sienna	Ultramarine blue	Vermilion
Aureolin	Leads	Cerulean	
Prussian blue	Zincs	Yellow ochre	
	Viridian		

TABLE 9

Converting temperatures

To convert centigrade into fahrenheit, multiply by 9, divide by 5, and add 32. To convert fahrenheit into centigrade, subtract 32, multiply by 5, and divide by 9.

TABLE 10

Conversion of weights and measures

To convert	to	multiply by
grams	grains	15.43
	drams	.56
	ounces	.0353
	pounds	.0022
kilograms	grains	15432.4
	drams	564.38
	ounces	32.15
	pounds	2.3
ounces	grams	28.35
	grains	437.5
	pounds	.0625
	troy ounces	.91
fluid ounces	milliliters	29.57
	fluid drams	8.
	liters	.03
	cubic inches	1.8
	gallons	.007818
liters	pints	2.11
	quarts	1.06
	cubic inches	61.025
	fluid drams	270.5
	gallons	.26
	fluid ounces	33.81
gallons	cubic feet	.134
	liters	3.785
	ounces	128.
	milliliters	3785.4
milliliters (cubic centimeters, CC's)	fluid drams	.27
	fluid ounces	.0338
	cubic inches	.061
	pints	.0021
	quarts	.001
pints	milliliters	473.179
	cubic feet	.017
	cubic inches	28.9
	gallons	.125
	liters	.473
quarts	milliliters	946.36
	cubic feet	.033
	cubic inches	57.75
	fluid drams	256.
	gallons	.25
	liters	.946
inches	centimeters	2.54
	meters	.0254
centimeters	inches	.3937
	feet	.0328

Directory of suppliers

Typical of American business, small enterprises either grow large or disappear entirely. Consequently, the painter experiences some difficulty in obtaining small quantities of uncommon materials. Many of these are available, but only from firms accustomed to dealing in hundreds of pounds or in carload lots; and it is often impossible to obtain these materials in smaller amounts.

However, neighborhood pharmacies have a surprising number of items you would never suspect; I strongly urge the painter to establish a friendly relationship with his pharmacist. These gentlemen seem to possess inquiring minds and to enjoy ferreting out sources of the most remote items. Industrial supply houses which deal in chemicals are frequently the only sources for obtaining volatile solvents; these firms take special precautions in storing and handling such materials.

Formerly, most art supplies could be ordered directly from the manufacturer, who has now grown too large to handle small orders. The painter must depend primarily upon the assistance of his favorite retailer to obtain materials not commonly stocked; most dealers are willing to seek out and order special materials for their customers.

GENERAL ARTISTS' SUPPLIES

The following firms will sell directly by mail to individuals:

PERMANENT PIGMENTS, INC.
2700 Highland Avenue, Norwood, Ohio 45212
Paints and mediums.

JOSEPH TORCH ARTISTS' MATERIALS
29 West 15th Street, New York, N.Y. 10011

General artists' supplies; specializes in fine papers.

UTRECHT LINENS, INC.
33 Thirty-fifth Street, Brooklyn, N.Y. 11232
Raw linen, prepared canvas, paints, and brushes.

WINSOR & NEWTON, INC.
555 Winsor Drive, Secaucus, N.J. 07094

General artists' supplies, including dry pigments and alkyd paints.

RESINS, OILS, GUMS, WAXES, ETC.

H. BEHLEN & BROS., INC.
P.O. 698, Amsterdam, N.Y. 12010

CITY CHEMICAL CORPORATION
132 West 22nd Street, New York, N.Y. 10011

DRY PIGMENTS

WINSOR & NEWTON, INC.
555 Winsor Drive, Secaucus, N.J. 07094

FEZANDIE & SPERRLE, INC.
111 Eighth Ave., New York, N.Y. 10011

SYNTHETIC RESINS

Acryloid B-67 MT, in a 45% solution with mineral thinner compatible with linseed oil, is sold by:

ROHM AND HAAS COMPANY
Resins Department
Independence Mall West
Philadelphia, Pennsylvania 19105

Acryloid B-67 MT (45% solution), Acryloid F-10 (40% solution) and Acryloid B-72 (50% solution) are available from this manufacturer in quart size or larger. They may be used as final picture varnishes.

Alkyd Oil Paints are manufactured by:

WINSOR & NEWTON, INC.
555 Winsor Drive, Secaucus, N.J. 07094

Elvacite™, is manufactured and sold in a dry, powdered form by:

DUPONT CO.
PP and R Department
Customer Service Center
Chestnut Run
Wilmington, Delaware 19898
Specify the grade of Elvacite desired.

Ethyl Silicate and *Tetraethyl Orthosilicate* are manufactured by:

UNION CARBIDE
270 Park Avenue, New York, N.Y. 10017
Write to Chemical Sales Department, Union Carbide, for the address of the outlet nearest you.

Bibliography

GENERAL REFERENCE WORKS

DOERNER, MAX, *Materials of the Artist*. Harcourt, Brace & World, N.Y., 1949.

GETTENS, RUTHERFORD J., and STOUT, GEORGE L., *Painting Materials*. Dover, N.Y., 1965.

MAYER, RALPH, *The Artist's Handbook of Materials and Techniques*. Viking Press, N.Y., 1957.

EGG TEMPERA

SEPESHY, ZOLTAN, *Tempera Painting*. American Studio Books, Holme Press, Inc., N.Y., 1946.

THOMPSON, DANIEL V., JR., *The Practice of Tempera Painting*. Dover, N.Y., 1962.

VICKREY, ROBERT, and COCHRANE, DIANE, *New Techniques in Egg Tempera*. Watson-Guptill Publications, N.Y., 1973.

ENCAUSTIC

PRATT, FRANCES, and FIZELL, BECCA, *Encaustic—Materials and Methods*. Lear, N.Y., 1949.

FRESCO

NORDMARK, OLLE, *Fresco Painting*. American Artists Group, Inc., N.Y., 1947.

ACRYLICS

BLAKE, WENDON, *Complete Guide to Acrylic Painting*. Watson-Guptill Publications, N.Y., 1971.

CARE AND PRESERVATION

BURROUGHS, ALAN, *Art Criticism from a Laboratory*. Little, Brown & Co., Boston, 1938.

CARE AND PRESERVATION

KECK, CAROLINE K., *A Handbook on the Care of Paintings.* Watson-Guptill, N.Y., 1967.

PLENDERLEITH, HAROLD J., *The Conservation of Antiquities and Works of Art.* Oxford University Press, London, 1956.

STOUT, GEORGE L., *The Care of Pictures.* Columbia University Press, N.Y., 1948.

DRAWING

WATROUS, JAMES, *The Craft of Old Master Drawings.* University of Wisconsin Press, Madison, Wisconsin, 1957.

HISTORICAL AND TECHNICAL

CENNINI, CENNINO D'ANDREA, *The Craftsmen's Handbook,* trans. by Daniel V. Thompson. Dover, N.Y., 1959.

CHURCH, A. H., *The Chemistry of Paints and Painting.* Seeley and Co., London, 1890.

LAURIE, A. P., *The Materials of The Painter's Craft.* T. N. Foulis, London, 1910.

LAURIE, A. P., *The Painter's Methods & Materials.* Dover, N.Y., 1960.

LAURIE, A. P., *The Pigments and Mediums of the Old Masters.* Macmillan and Co., London, 1914.

EASTLAKE, CHARLES L., *History of Oil Painting.* Dover, N.Y., 1960. 2 vols.

THOMPSON, DANIEL V., JR., *The Materials and Techniques of Medieval Painting.* Dover, N.Y., 1956.

VERY INTERESTING

CHAET, BERNARD, *Artists at Work.* Hill & Wang, N.Y., 1961.

KNAGGS, NELSON S., *Adventures in Man's First Plastic: The Romance of Natural Waxes.* Reinhold, N.Y., 1947.

RUHEMANN, H., and KEMP, E. M., *The Artist at Work.* Penguin Books, Baltimore, 1951.

Index